100 Pre-Raphaelite Masterpieces

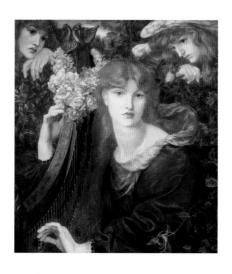

Publisher and Creative Director: Nick Wells

Project Editors: Chelsea Edwards and Polly Prior

Art Director: Mike Spender **Layout Design:** Nik Keevil

Digital Design and Production: Chris Herbert

Special thanks to: Laura Bulbeck, Catherine Taylor and Digby Smith

11 13 15 14 12 1 3 5 7 9 10 8 6 4 2

This edition first published 2011 by

FLAME TREE PUBLISHING

Crabtree Hall, Crabtree Lane Fulham, London SW6 6TY United Kingdom

www.flametreepublishing.com

Flame Tree Publishing is part of The Foundry Creative Media Co. Ltd

© 2011 this edition The Foundry Creative Media Co. Ltd

ISBN 978-0-85775-251-2

All rights reserved. No part of this publication may be reproduced, stored in a retrieval system, or transmitted in any form or by any means, electronic, mechanical, photocopying, recording or otherwise, without the prior permission in writing of the publisher.

A CIP record for this book is available from the British Library upon request.

Every effort has been made to contact copyright holders. We apologize in advance for any omissions and would be pleased to insert the appropriate acknowledgement in subsequent editions of this publication.

While every endeavour has been made to ensure the accuracy of the reproductions of the images in this book, and would be grateful to receive any comments or suggestions for inclusion in future reprints.

Printed in China

100 Pre-Raphaelite Masterpieces

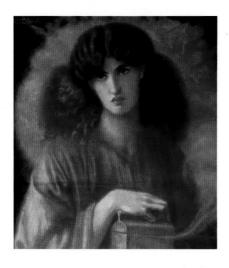

Gordon Kerr

FLAME TREE PUBLISHING

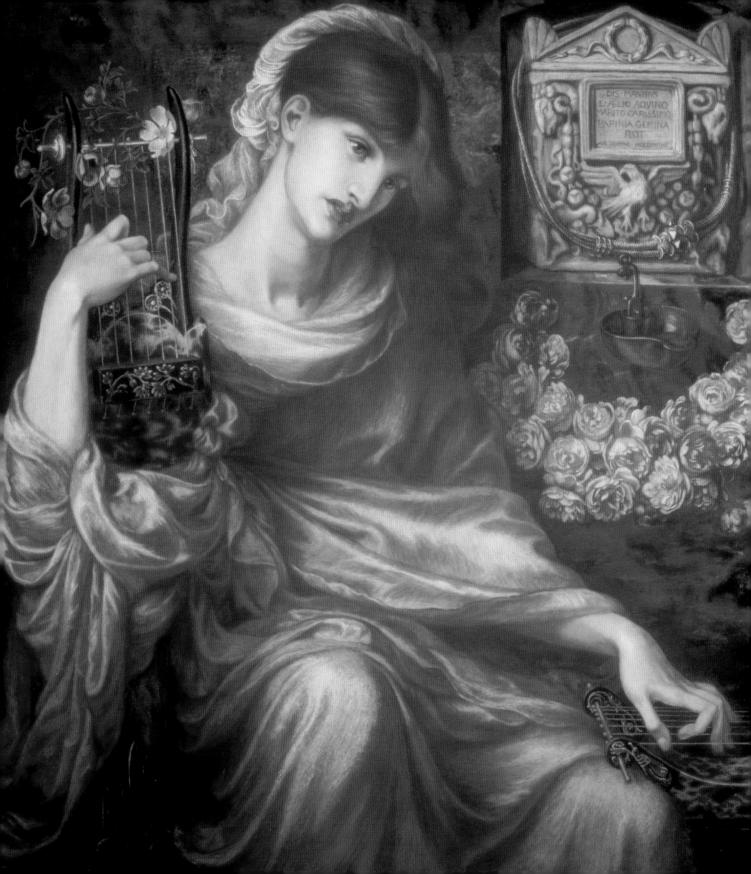

Contents

Movement Overview	6
Society	14
Places	24
Styles & Techniques	30
The Masterpieces	36
Index of Works	142
General Index	143

Movement Overview

OR OVER 50 YEARS, AT THE END OF the nineteenth century, British art was dominated by the Pre-Raphaelite Brotherhood, a revolutionary art movement that approached painting in a vastly different way to the academic style that was currently in vogue. This initially secret organization was created by three remarkable young men whose work would go on to influence a great deal of what followed in the world of art and that would, by the end of the nineteenth century, have infiltrated much of British cultural life.

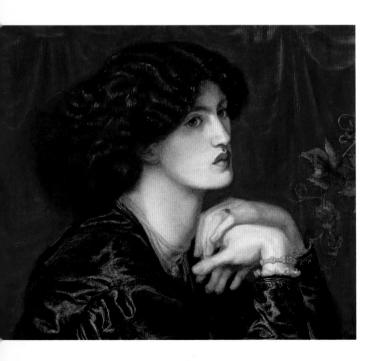

The Pre-Raphaelite Brotherhood

The PRB, as its adherents liked to call it, set out in 1848 with the objective of reforming British art, represented at the time by the country's principal art institution, the Royal Academy of Arts. After several years of stubborn resistance and ridicule from an uncomprehending art world and public, the artists of the PRB began to achieve recognition and acclaim, due in part to the advocacy of the pre-eminent art critic of his day: John Ruskin (1819–1900).

Original Members

- The Pre-Raphaelite Brotherhood was launched in 1848 by three earnest and rebellious young artists: Dante Gabriel Rossetti (1828–82), William Holman Hunt (1827–1910) and John Everett Millais (1829–96). All three were products of the academic system, having attended the Royal Academy schools, but each wanted to bring about change in the art world.
- The organization they founded effectively disbanded after only five years and the principal members then followed very different paths to each other. By that time, however, they had already launched a revolution that would change art forever.

Dante Gabriel Rossetti

- Dante Gabriel Rossetti was born in London in 1828, son of an Italian poet and professor of Italian at King's College, who had been forced to flee Italy due to his support for Italian revolutionary nationalism. Rossetti senior, a devoted scholar of the medieval Italian poet Dante, married a half-Italian teacher with whom he had four children, all of whom would distinguish themselves in the fields of literature and art: William Michael (1829–1919), like his brother, a member of the Brotherhood, became a well-known writer and critic; Christina (1830–94) became a celebrated poet and Maria (1827–76) became a nun, but is remembered for an important essay on Dante.
- The Rossetti children grew up surrounded by literature, art and politics and the young Dante was the most precocious of all.

Throughout his early life, he was unsure to which art form he should direct his considerable talents – painting or literature. Fortunately, it was a choice he never made and posterity has benefited from his work in both.

He elected to study at the Académie Suisse, run by former artist's model, Père Suisse, who provided an informal environment in which artists could work without any input or criticism from a teacher. They were free to use whatever medium they wished and were allowed to draw from life, something that was not permitted in the more formal schools until the student spent many years drawing plaster casts of Classical sculptures.

Royal Academy Schools

- Aged 13, he left school to attend Sass's Academy, a preparatory school for prospective Royal Academy students. He would spend much of his time there reading and illustrating scenes from Shakespeare, Goethe, Walter Scott and Byron. Four years later, in 1845, he entered the Royal Academy Schools as a probationary student and a year later he was enrolled as a full-time student.
- The Academy style, however, was anathema to the lazy and impetuous but creatively brilliant and charismatic young man and he stopped attending lectures. He became a pupil of the artist Ford Madox Brown (1821–93) whom he greatly admired but Rossetti, eager to tackle weightier subjects than the still-lives Madox Brown assigned him, soon became bored. In 1848, he attended the Royal Academy Summer Exhibition where he saw a painting that delighted him The Eve of St Agnes by fellow student, William Holman Hunt (see right and page 39). The two became friends and later that year he and Hunt rented a studio in Cleveland Street, London. There, Hunt helped Rossetti complete his first Pre-Raphaelite work, The Girlhood of Mary Virgin.

William Holman Hunt

The intensely religious Hunt lacked the pure natural talent of Millais and certainly did not possess the charisma of Rossetti but he played a vital role in the early days of the Brotherhood and remained true to Pre-Raphaelite principles throughout his career.

Hunt was born into a humble background in 1827 and, at the age of 12 was sent out to work as a clerk. However, he spent every minute of his spare time painting, saving whatever he could to put towards tuition. Accepted as a probationary student at the Royal Academy, he encountered there the precocious talent that was John Everett Millais, the third member of Pre-Raphaelitism's founding triumvirate.

John Everett Millais

Millais was, without doubt, the most naturally gifted of the three and one of the most technically brilliant artists that Britain has ever produced. From winning a silver medal from the Royal Society of Arts when he was only nine years old, to becoming President of the Royal Academy in the final year of his life, his career was nothing but a success story, apart from the two years – 1850 and 1851 – when the critics were pouring vitriol on the work of the Pre-Raphaelites.

Born into a Jersey family in 1829, he enrolled at the Royal Academy at the remarkably early age of 11, the youngest student in the institution's history. It soon became evident that he had a facility for mastering any technique and at the age of 18, he was awarded a Royal Academy gold medal. Shortly after, he met Hunt and Rossetti.

A Secret Organization

- The three young artists began to meet regularly to exchange views on art. They discovered that they shared similar views about the state of the art world and decided to form a secret organization, to be known as the Pre-Raphaelite Brotherhood. They invited four others to join. Rossetti brought in his brother William Michael who would become the organization's chronicler. He would go on to edit *The Germ*, the PRB's short-lived literary magazine and became a successful biographer and critic.
- Painter James Collinson (1825–81), art critic Frederic George Stephens (1828–1907) and sculptor Thomas Woolner (1825–92) took the number of members to seven.

The Philosophy

- At the Pre-Raphaelites' founding meeting, William Michael Rossetti recorded their aims as:
- 1. To have genuine ideas to express;
- 2. To study nature attentively, so as to know how to express them;
- To sympathize with what is direct and serious and heartfelt in previous art, to the exclusion of what is conventional and self-parading and learned by rote;
- **4.** And most indispensable of all, to produce thoroughly good pictures and statues.
- There were precursors for this type of approach, one that looked back to a time when art was fresher and more direct. PRB members would have been fully aware of the Nazarenes, founded in the early nineteenth century, a group of German artists who had dedicated their lives to rejuvenating religious art in the spirit of early German and Italian painters.

A Fresh Approach

- Joshua Reynolds (1723–92), artist and first president of the Royal Academy, to be especially pernicious. They called him 'Sir Sloshua' and according to William Michael, the term 'sloshy' came to mean for them, 'anything lax or scamped in the process of painting...and hence...any thing or person of a commonplace or conventional kind.'
- The young artists of the PRB were tired of the triviality of the works being exhibited by the Academy: 'Monkeyana ideas, Books of Beauty and Chorister Boys', as Hunt later described them.

 Rather, they wanted to paint works that changed and inspired minds and hearts. Instead of the trickery taught by the Academy, they championed fidelity to nature, using models and painting out of doors, echoing the philosophy of the art critic John Ruskin.

This realist approach would jar slightly, however, with the PRB's fascination with the medieval culture that they believed possessed a spiritual and creative integrity that had been lost.

Critical Reception

- Rossetti was the first of the Brotherhood to exhibit. The Girlhood of Mary Virgin was shown about a month before the opening of the Royal Academy's annual exhibition. Nazarene in its approach, and packed with symbolic meaning, it was given a favourable reception by critics.
- A month later, more PRB paintings were exposed to public scrutiny at the 1849 Royal Academy show. Hunt showed Rienzi..., while Millais selected literary subjects Jsabella (see right and page 40) and Ferdinand Lured by Ariel (see page 43), drawn from Keats and Shakespeare respectively. The letters 'PRB' were mysteriously appended to the signatures on these three works. The critics were not averse to what they believed to be credible attempts in the Italian style, the Art Journal praising Isabella for having the 'feeling of the early Florentine school' and all three sold. Millais wrote confidently to Rossetti that 'the success of the PRB is now quite certain'.

PRB Uncovered

The following year, however, the meaning of the letters 'PRB' became public knowledge, possibly as a result of Rossetti gossiping to a sculptor who passed it on to a journalist. There was a furious reaction from the art establishment that considered it highly presumptuous of young, inexperienced artists to take such a stand, especially in the form of a secret society. Knowledge of the Pre-Raphaelite Brotherhood was further widened in early 1850 with the publication of *The Germ*, the Brotherhood's magazine.

Shocking Reception

The Germ was an undiluted flop. By the time it had closed down after just four issues, however, the art world knew all about Pre-

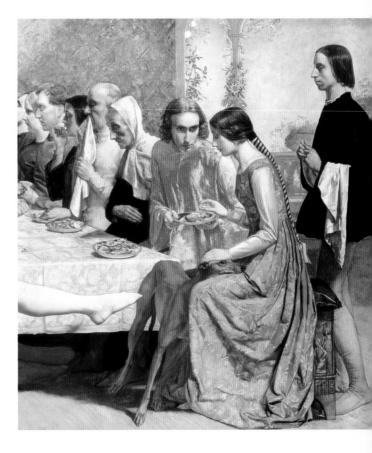

Raphaelitism, and it did not like it. The next time their works were shown, at the 1850 Free Exhibition, they received a critical roasting. Millais' *Christ in the House of His Parents* (see next page and page 42), one of a number of Pre-Raphaelite works shown at the Royal Academy that summer, was then savaged. 'Mr Millais' principal picture is, to speak plainly, revolting,' thundered *The Jimes*. In *Household Words* magazine, Charles Dickens described the paintings of the PRB as 'mean, repulsive and revolting' citing Millais' painting in particular. Not one of their pictures sold and the Pre-Raphaelites were shocked by the reaction to their work. Rossetti was so horrified that he swore never to exhibit in public again.

They returned at the 1851 exhibition but were again subjected to extraordinarily vitriolic treatment, the *Athenaeum* describing them as 'a class of juvenile artists'.

The defining moment of Pre-Raphaelitism arrived, however, when, England's leading art critic, John Ruskin, was persuaded to intervene on their behalf. In May 1851, Ruskin penned two letters to *The Times* in which he gave his support to the PRB. From then on, their fortunes changed.

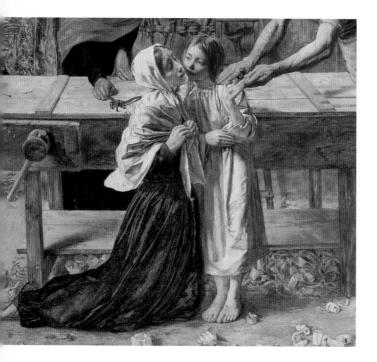

The Brotherhood Breaks Up

The break-up of the Pre-Raphaelite Brotherhood as a cohesive unit was inevitable, given the very different directions its members were taking.

Collinson Resigns

James Collinson was a devout Christian who had converted to Catholicism but returned to Anglicanism in order to become engaged to Rossetti's sister Christina. In spring 1850, however, he reverted to Catholicism, leading Christina to break off the engagement. As a result of this, on top of accusations that Millais' painting Christ in the House of His Parents was blasphemous, Collinson resigned from the Brotherhood.

Walter Howell Deverell

The remaining members believed that Collinson's place should be filled, keeping their number at seven. Consequently, Walter Howell Deverell (1827–54) was invited to join. However, there was a lack of general agreement about this and, as William Michael Rossetti later said, 'it could not be said that Deverell was ever absolutely a PRB'. Millais had been keen for his friend, Charles Alston Collins (1828–73) to be invited to fill Collinson's place. Millais was working with him that summer around Oxford, painting two important works, The Woodman's Daughter (see page 52) and Mariana (see page 51) while Collins was painting his Convent Thoughts (see page 48), showing a nun contemplating a passion flower symbolizing the crucifixion of Christ. Collins' painting is important in that, in his letter to The Times on 13 May 1851, Ruskin singled it out for particular praise, adding 'I wish that it were mine'.

Stephens and Woolner Depart

- Next to go was Stephens, who became an art critic. Finally, unable to earn a living from sculpture, Thomas Woolner decided in 1851 to emigrate to Australia with his family to seek his fortune in the newly discovered gold fields. When this proved even less financially viable than sculpture, he returned to England to forge a successful career as a sculptor of portrait busts. As a Pre-Raphaelite he was a minor figure but he did make one valuable, although indirect, contribution. To mark his departure for Australia, PRB sympathizer Ford Madox Brown, painted one of the movement's and one of the nineteenth century's most iconic works: The Last of England (see page75).
- There was growing disagreement about how the Brotherhood should function and Millais questioned the entire organization, wondering if they did actually have anything in common and in 1853 there was only one meeting of the Brotherhood.

 William Michael noted that it was possibly the success of Pre-Raphaelitism that was bringing about its break-up: 'our position is greatly altered. We have emerged from reckless abuse to a position of general and high recognition'.

Commitment to the Brotherhood?

- Most successful of all was John Everett Millais. His painting A Huguenot (see page 58), depicting a pair of young lovers in embrace, the girl trying unsuccessfully to persuade her lover to don a white armband signalling his allegiance to Catholicism, proved extraordinarily popular. Exhibited with the beautiful Ophelia (see page 55) in 1852, a painting now estimated to be worth around £30 million, this work helped to further change attitudes towards Pre-Raphaelitism.
- Millais' commitment to the PRB became questionable the following year, however, when he was elected an Associate of the Royal Academy. Disgusted, Rossetti wrote to his sister Christina, '...so now the whole Round Table is dissolved.' Millais' interest in subjects such as *The Order of Release*, 1746 of 1853 and *The Black Brunswicker* (see page 94) of 1860 show him choosing much more popular subjects; he would eventually move away altogether from Pre-Raphaelitism, painting, to the horror of Ruskin who termed it a 'catastrophe', in a much broader style.
- In 1854, Hunt left for the Holy Land, effectively marking his separation from the Brotherhood. There, he would paint such works as *The Finding of the Saviour in the Temple (see* page 72) and the astonishingly uncompromising *The Scapegoat (see* page 71) which was greeted by critics with bewilderment.

Pre-Raphaelite Followers

- By this time, however, the Pre-Raphaelite movement was collecting a number of followers, amongst whom were Henry Alexander Bowler (1824–1903) and watercolourist John Frederick Lewis (1805–76), while sympathizers such as William Dyce (1806–64), Ford Madox Brown and Charles Alston Collins also worked in a Pre-Raphaelite manner.
- Another of these converts was Arthur Hughes (1832–1915). Hughes was a follower, not a trend-setter and his work was about love and sweet sadness. His *April Love* (see page 66) and *The Long Engagement* (see page 90) are romantic paintings, while his best-known picture, *Home from the Sea* (see page

96), showing a young sailor coming home to find his mother has died in his absence, verges on the overly sentimental.

The Founder Brothers

Hunt exhibited two pictures at the 1854 Academy exhibition: The Light of the World (see below and page 67) and The Awakening Conscience (see page 60) – which were initially badly received. Once again Ruskin had to intervene, describing the former as 'one of the very noblest works of sacred art ever produced in this or any other age'.

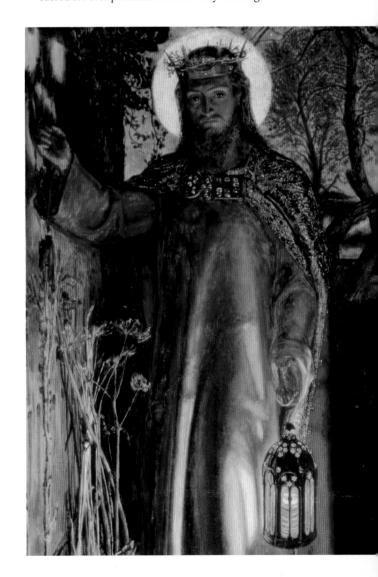

Meanwhile, Rossetti was moving in a different direction. He had fallen in love with a model – Elizabeth Siddal (1829–62) – who had been discovered behind the counter of a milliner's shop. He would draw and paint her countless times – as in *Portrait of Elizabeth Siddal* (see page 68) – and eventually marry her. Tragically, she committed suicide, in 1862, aged 32. Between 1864 and 1870, he painted the intense and beautiful Symbolist painting *Beata Beatrix* (see page 99) as a memorial to her.

The Second Phase of Pre-Raphaelitism

In 1855–56, Rossetti first met two young students: William Morris (1834–96) and Edward Burne-Jones (1833–98). Morris, although not a Pre-Raphaelite, sympathized with the PRB's objectives and techniques. He would become one of the most significant figures of late Victorian culture. Burne-Jones, on the other hand, was possibly more of a Pre-Raphaelite than Millais or Madox Brown.

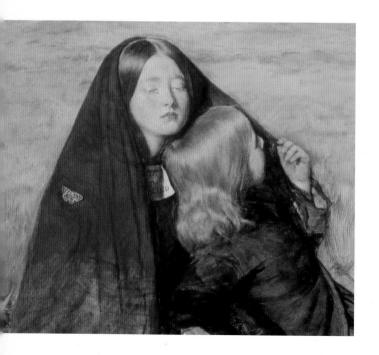

Fresh Impetus

This meeting would give fresh impetus to Pre-Raphaelitism and marked the beginning of its second phase in which a number of artists would play an important role, including John Roddam Spencer Stanhope (1829–1908), Marie Spartali Stillman (1844–1927), Evelyn De Morgan (1855–1919), Ford Madox Brown, John William Waterhouse (1849–1917) and Sir Lawrence Alma-Tadema (1836–1912). It was through Morris and Burne-Jones, however, that Pre-Raphaelitism would briefly revive and blossom anew in a different guise – that of the Aesthetic Movement. Once again, Rossetti was a dominant figure but he would fade from view as his health declined in the 1870s and he increasingly painted single, voluptuous *femmes fatales* that seemed wanton to the prim Victorians. In 1882, he died of an addiction to the sedative chloral.

Pre-Raphaelites Old and New

Burne-Jones met Rossetti at a painting class the older artist was teaching in 1855 and was persuaded by him to leave Oxford without a degree to become a painter. In 1857, Morris and Burne-Jones were members of the group of painters that Rossetti assembled to paint a group of murals for the Oxford Union. Also in 1857, at an exhibition of British art in the United States, the Pre-Raphaelite paintings on show – although there were none by Rossetti or Millais – created excitement. That year, too, Rossetti and Hunt fell out over Hunt's model, Annie Miller (1835–1925), with whom Rossetti had been dallying. Two other women, Fanny Cornforth (1835–*c*. 1906) and Jane Burden (1839–1914) – wife of William Morris, would further add to the complexities of Rossetti's love life around this time.

Continuing Success

In 1858, Millais exhibited *The Blind Girl* (see left and page 79), a picture true to the Pre-Raphaelite aesthetic that brought unqualified praise for the PRB leaders from John Ruskin in a letter to the *Liverpool Albion*. 'Since Turner's death,' he wrote, I consider that any average work from the hand of the four leaders of Pre-Raphaelitism...[Ruskin added the painter John Frederick Lewis to the triumvirate]...is singly, worth at least three of any other pictures whatever by living artists.'

Morris, Marshall, Faulkner & Co.

In 1861 the interior design company, Morris, Marshall, Faulkner & Co., in which key Pre-Raphaelites such as Rossetti would become involved, was founded. The firm designed furniture, architecture, interiors, tapestries, wallpaper and stained glass. It gained recognition as early as 1862 at the International Exhibition in London and Morris was encouraged by this to continue to develop his design philosophy of Arts and Crafts that advocated the use of traditional craftsmanship and medieval, romantic or folk decorative themes.

Burne-Jones Finds His Way

Meanwhile, Burne-Jones threw off the influence of Rossetti and introduced his own vision, the enchanting dreamworld of Aestheticism, as can be seen in his painting *The Beguiling of Merlin* (see right and page 128), one of eight exhibited at the Grosvenor Gallery in 1877, in the show that made his name. With Pre-Raphaelitism the pre-eminent aesthetic of the time, his fortunes began to rise and he remained unremittingly prolific. He often painted in series, the best known being the 'Briar Rose' series, featuring the story of *The Sleeping Beauty* (see page 119). He occupied a central position in the Aesthetic Movement and was knighted in 1894, a rare honour for an artist.

Lasting Influence

Although the PRB, as an active, participatory organization, was short-lived, its impact was extensive and it undoubtedly influenced a great deal of the art that was to follow. It pervaded Victorian culture from the 1860s and many artists followed the lead of the young men who had invented it until it was the prevailing aesthetic of its time. Its influence was not just in the field of painting; it spread into other areas, especially through the efforts of William Morris and his companies, using not just the Pre-Raphaelite philosophy and its themes, but also employing its practitioners to help create many of the products for which his company became famous. Rossetti, Ford Madox Brown and Edward Burne-Jones became partners in the company.

Influential Movement

Meanwhile, Rossetti, one of the great creative geniuses of his time, came later to be seen as a precursor of the important European Symbolist movement which believed that art should represent absolute truths, which can be described only indirectly using symbolic imagery. In the 1970s, the Brotherhood of Ruralists, a British art group that featured Sir Peter Blake (b. 1932) amongst its founding members, based its aims on Pre-Raphaelitism; the Stuckists have also claimed to have derived inspiration from the PRB.

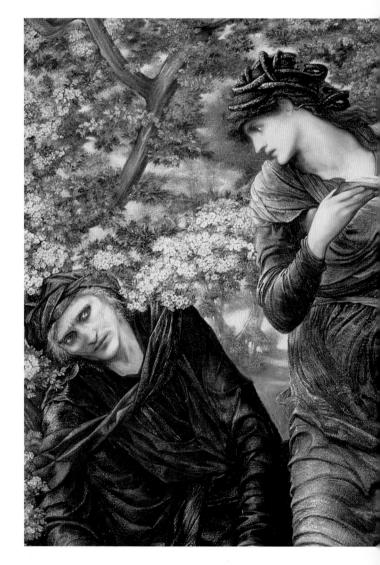

Society

HE VICTORIAN ERA WAS A TIME of enormous change: the Industrial Revolution had created great wealth, but also massive poverty and social injustice; technological advances saw the improvement of the printing press and the British Empire was reaching its apogee. Despite one of the PRB's aims to move away from the academic style that pervaded art at that time, the artists could not remove themselves from the society in which they lived.

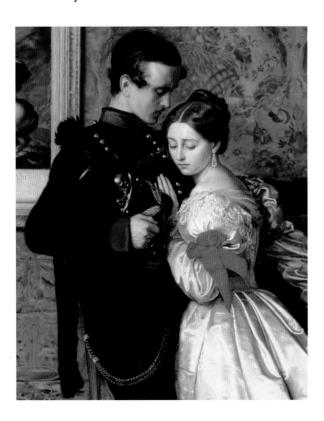

Victorian Art

The nineteenth century saw a great deal of change in art, especially from the middle of the century when the Pre-Raphaelites began to actively challenge the precepts of the Royal Academy. However, possibly of even greater significance were the actions of reformers to make art accessible. Until the nineteenth century, art was in the hands of an elite but one of the great triumphs of the Victorian age was the creation, through both private philanthropy and government funding, of public art galleries not just in London, but in cities throughout the country.

The National Gallery

'improve the taste of the public', proved immensely popular, admitting more than 700,000 visitors by 1848. The Tate Gallery, built to house British art, was opened in 1897. But what would go in it? What kind of art was produced during the 64 years of Queen Victoria's reign?

Conservative Art

The age of innovation and invention, of steam power, steel, machines, empire and reform was echoed in the ground-breaking works of Joseph Mallard William Turner (1775–1851). Turner was unafraid to depict elements of the great changes that were taking place around him, as he demonstrated in remarkable, impressionistic paintings such as Rain, Steam and Speed - The Great Western Railway. Victorian painters, however, were content to leave this type of ground-breaking work to Turner. Victorians, it seemed, did not want their art to remind them of industrialization, of factory chimneys and the new modes of transport. Indeed, Victorian art often erred on the side of caution, producing work that was unfailingly conservative and often simply escapist. Paintings told stories that emphasized family values and extolled the virtues. They were often mawkishly sentimental, using war and disaster to spark the emotions.

All things Classical were acceptable as subject matter. The Medieval world, too, featured, as did children, animals and scantily clad women. Fairies and other woodland beings were not uncommon. Often, it could be described as 'chocolate box'.

Establishment Artists

Amongst artists of the period who did not fall into the Pre-Raphaelite camp were John Emms (1844–1912), famous for his paintings of dogs and horses; Sir Samuel Luke Fildes (1843–1927); Walter Crane (1845–1915); painter and President of the Royal Academy, Sir Edward John Poynter (1836–1919); Henrietta Rae (1859–1928); and the sculptor of the lions in Trafalgar Square as well as painter of the enduringly popular *The Monarch of the Glen*, Sir Edwin Henry Landseer (1802–73). Throughout, of course, the ultra-conservative Royal Academy reigned supreme.

The Royal Academy

The Pre-Raphaelite revolution had its genesis in the heart of the enemy, the Royal Academy of Art, which was founded in 1768, with the painter Sir Joshua Reynolds as its first President. Its mission was to promote art through education, debate and exhibition and to raise the professional status of the artist and the architect in Britain. It opened the first national school of art and planned to exhibit contemporary works of art that had achieved a recognized standard and that satisfied prevailing notions of good taste.

Backing British Art

Until that time, there were few opportunities for British contemporary artists to sell their work, arbiters of fashion in Britain generally favouring continental and traditional art forms. The first venue at which contemporary British art could be appreciated was at the Foundling Hospital, where the artist William Hogarth (1697–1764) established a permanent art exhibition on the walls of the institution. Hogarth's success led to the establishment of the Society of Artists and the Free Society of Artists which were primarily exhibiting

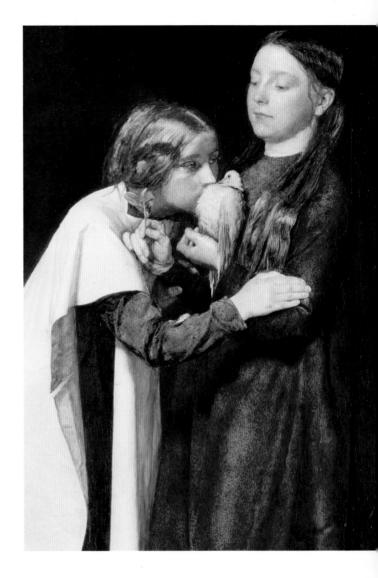

organizations. The Royal Academy's combination of education and exhibition, however, was an entirely different concept. Amongst its founding academicians were Thomas Gainsborough (1727–88), Richard Wilson (1713–82) and Johann Zoffany (1733–1810).

The Royal Academy's first exhibition was held in 1769 and, now known as the Royal Academy Summer Exhibition, and recognized as an internationally important exhibition of contemporary art, has been held every year since.

Royal Academy Schools

Its educational wing, the Royal Academy Schools was the first institution to offer professional training for artists in Britain. Based on the French Académie de Peinture et de Sculpture that was founded by Louis VIV in 1648 and shaped by guidelines devised by Sir Joshua Reynolds, it stressed the copying of the Old Masters and aimed to produce artists of not only great ability but also high moral character. Amongst those taught there were J.M.W. Turner, Sir John Soane (1753–1837), William Blake (1757–1827) and John Constable (1776–1837).

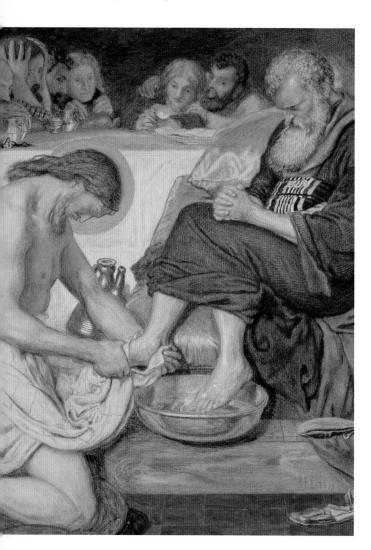

By the time Millais, Hunt and Rossetti walked through its doors as eager young students, the Royal Academy was the dominant force in every facet of British art.

John Ruskin

- 'We cannot censure at present as amply or as strongly as we desire to do, that strange disorder of the mind or the eyes which contributes to the rage with unabated absurdity among a class of juvenile artists who style themselves PRB...'
- Thus did the *Athenaeum* snarl at the Pre-Raphaelite
 Brotherhood following the 1851 Royal Academy exhibition.
 There was a feeling that the young artists were being different for its own sake, or as *The Times* put it, that they were sacrificing 'truth as well as feeling to eccentricity'. It was at this point that the influential art critic John Ruskin entered the fray.
- Ruskin was born in London in 1819, the son of a wine importer.

 As a child his intellect was carefully nurtured by his parents who denied him toys or the company of other children. Aged six, he toured European capitals with his parents, sketching, writing and delivering opinions on all he saw. He studied at King's College, London, and Christ Church, Oxford, where he won the Newdigate Prize for poetry.

Modern Painters

important works, *Modern Painters*, in which he argued that painters of landscapes, such as Turner, were superior to the Old Masters, a contentious claim, given that Turner's late works, which verged on the abstract, were being denounced by critics. Ruskin criticized the Old Masters because they had not been in the habit of 'going to nature' which, he argued, Turner did. Their paintings were concocted in the studio, not in front of the subject out of doors in all weathers and conditions. He urged artists to observe what he described as the 'truths of natural things'.

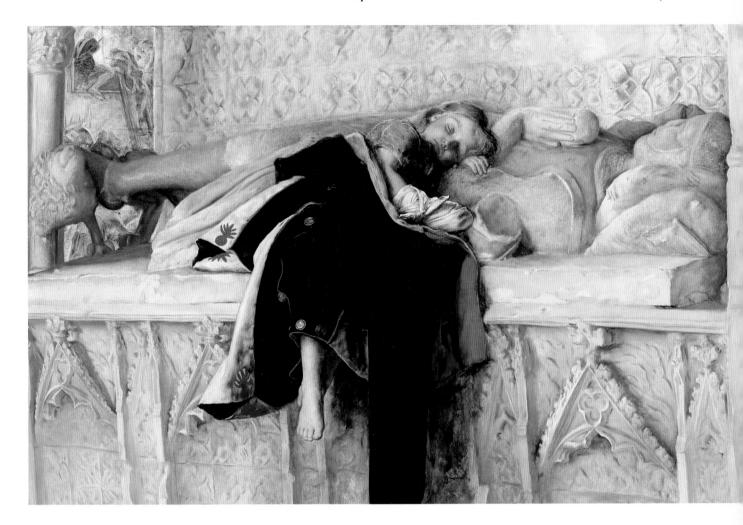

Ruskin Adds His Voice

- After being approached by Coventry Patmore, Ruskin, by now the most influential cultural pundit of his day, in May 1851 wrote two famous letters to *The Times*. He made it immediately clear that he had no personal axe to grind, that he had 'no acquaintance with any of these artists...and only very imperfect sympathy with them'. He was actually deeply suspicious of their religious stance, what he termed their 'Romanist and Tractarian tendencies'. He took issue with the critics, however, over their failure to appreciate 'the finish of drawing and splendour of colour' of what he called 'admirable though strange pictures' and went on to praise their attention to natural detail.
- His second letter expressed the hope that the Pre-Raphaelites 'may, as they gain experience, lay in our England the foundation of a school of art nobler than the world has seen for three hundred years'. It was a remarkable commendation from the most important voice in British art.

Recognizing Genius

but the artist remained reluctant to fall under the critic's spell, stubbornly refusing to recognize Turner's greatness and turning down an offer to accompany Ruskin and his wife to Switzerland. He did, however, agree to join the Ruskins on a trip to Scotland in 1853 during which he painted a portrait of Ruskin.

An Auspicious Trip

- They stayed at Glenfinlas, near Brig o'Turk in the Trossachs, and Millais began what became a celebrated portrait, Ruskin standing on some rocks beside a stream. It was a classically 'Ruskinian' style of portrait, featuring as it did so many elements of nature the rocks and boulders and the water frothing and broiling behind him.
- The trip was auspicious, however, for more than the portrait.

 Ruskin had married Effie Gray (1828–97) in 1848 but the marriage had never been consummated. During the stay at Glenfinlas, Effie and Millais fell in love, leading to scandalous and protracted divorce proceedings, her marriage to Ruskin being annulled in 1854 on the grounds of his 'incurable impotency' although he disputed this. Millais and Effie married the following year.

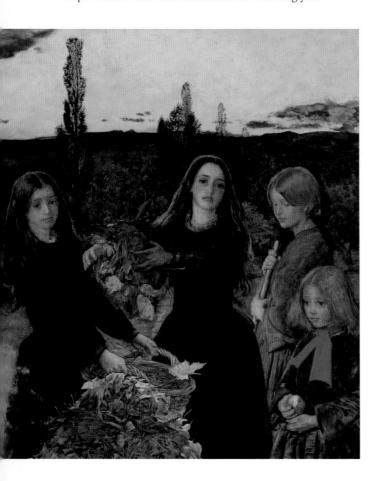

Praise Indeed

- Nonetheless, Ruskin graciously praised the outstanding paintings Millais showed at the 1856 Royal Academy show: *The Blind Girl, Autumn Leaves* (see left and page 80) and *Peace Concluded* (see page 81). The following year, however, he savaged Millais' *A Dream of the Past: Sir Jsumbras at the Ford* (see page 83).
- In 1878, Ruskin became embroiled in another scandal after he had scathingly reviewed paintings exhibited by James McNeill Whistler (1834–1903) at the Grosvenor Gallery. Seeing Whistler's *Nocturne in Black and Gold: The Falling Rocket* he famously accused him of 'asking two hundred guineas for throwing a pot of paint in the public's face'. Whistler sued for libel and won, and Ruskin's reputation was irredeemably tarnished.
- With the emergence of the Aesthetic Movement and Impressionism, Ruskin became less relevant but his contribution in 1851 to the perception of the Pre-Raphaelites represented a turning point in the understanding and appreciation of their work.

The Industrial Revolution – A Changing Society

The middle years of the nineteenth century brought phenomenal change not only to Britain but also to much of Europe and Latin America. 1848, the year that the Pre-Raphaelite Brotherhood launched its own revolution in the art world, more famously became known as the year of revolutions in the politics of numerous countries, a year in which dynasties crashed and a hunger for social justice was in the air. Dissatisfaction with political leadership boiled over in around 50 countries, coupled with demands for greater democracy, discontent amongst the less well-off working classes and an upsurge in nationalism. It began in France, before spreading to Austria, Hungary, Italy, Germany and many other countries.

Year of Revolution

- Revolutionary fervour was more muted in Britain, the middle classes having been placated by the 1832 Reform Act which greatly increased the number of people entitled to vote and did away with such abuses as 'rotten boroughs'. Nevertheless, trouble arose following the repeal of the Corn Laws which had protected grain prices, while the Chartists continued to agitate for political reform. They staged a rally on Kennington Common in South London in April 1848, attended by an estimated 100,000 people, amongst whom were William Holman Hunt and John Everett Millais.
- In 1848, too, Karl Marx and Friedrich Engels wrote *The Communist Manifesto*, forecasting the downfall of capitalism and the rise of socialism. The Industrial Revolution, with its rapid industrialization and the social impact this had on Britain, made the need for reform all the more urgent. The

workforce was exploited and living and working conditions were a national disgrace. An example of the Pre-Raphaelite reaction to this state of affairs can be found in Henry Wallis's (1830–1916) *The Stonebreaker* (see below and page 84), a harrowing denial of the proverb, beloved of the Victorians, that 'hard work never hurt anyone'.

Deprivation and Poverty in Victorian Britain

Between the beginning of the nineteenth century and its end, the population of Great Britain increased threefold. Various reasons have been given for this: people having larger families; more children surviving beyond infancy; people living longer; immigration, especially Irish people fleeing the potato famine, and unemployment. Of course, most of the

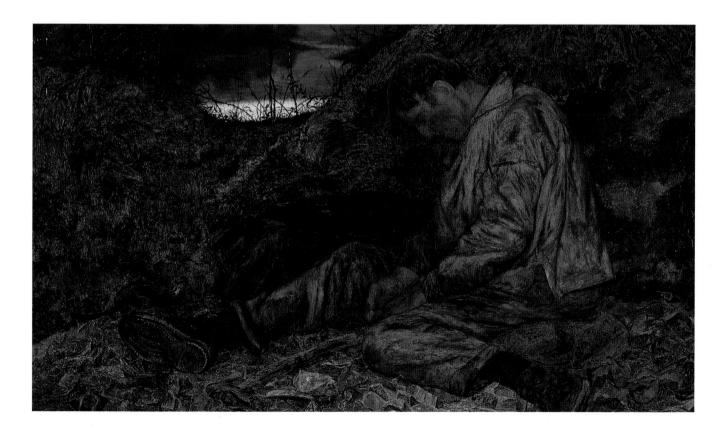

increased population was living in the country's towns and cities where they had gone in search of work and a better life. With such a readily available workforce, employers were able to pay low wages and lay workers off at will.

Child Labour

One of the great scandals of the age was child labour. Children contributed to the family budget by working long hours, often in horrific conditions, the worst examples possibly being the young boys employed by chimney sweeps or children working deep underground in coal mines. Often, too, children were thrown out of their homes by parents who could not afford to

feed them or who were incapable of looking after them. It was reckoned that there were around 30,000 homeless children on the streets of London alone. To make matters worse, housing was scarce and overcrowded, with many people living in just one room. In cities, large houses were split into flats and soon, due to the overcrowding and neglect by landlords, they became slums. Sanitation was non-existent and even clean drinking water was rare.

Someone Else's Problem

Attitudes to poverty were harsh at the start of the Victorian era. It was widely believed that it was an individual's personal

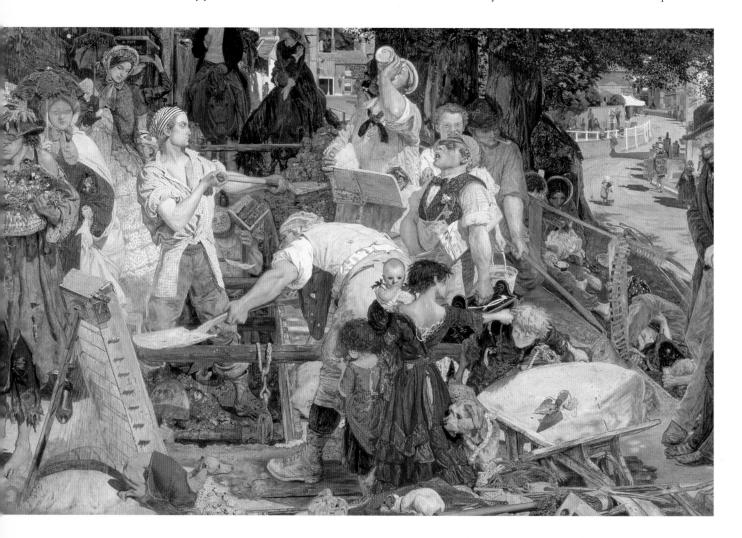

responsibility to keep him or herself out of poverty and if he failed to do so, it was thought to be the result of a character defect rather than economic forces. The poor were frequently regarded as little better than criminals and were often treated as such.

The governments of the day adopted a *laissez faire* approach, claiming that it was not its role to interfere in the life of the individual. As a result, it was up to reformers and the many charitable organizations that were formed at this time to work hard to overcome these huge social problems. As the century progressed, there were improvements, often funded by philanthropy. Government legislation – The Factory and Mines Acts, Education Acts and Public Health Acts – also finally began to improve the lot of the working class.

Social Commentary

- The Pre-Raphaelites were not afraid of social commentary in their work. Hunt's 1853 painting, The Awakening Conscience (see page 60), for instance, dealt with the huge problem of prostitution, although he was attacked for this by the Athenaeum which described the work as being 'drawn from a very dark and repulsive side of domestic life'. Hunt, who had come up with the subject after reading Charles Dickens' David Copperfield, said of it, 'I arranged two figures to represent the woman recalling the memory of her childhood home, and breaking away from her gilded cage with a startled holy resolve, while her shallow companion still sings on, ignorantly intensifying her repentant purpose'.
- Ford Madox Brown provided a commentary on the place of labour in contemporary society in his painting <code>Work</code> (see left and page 63) which shows a scene in Hampstead of a gang of men digging up a road, surrounded by the various layers of British society. One of the most striking of the Pre-Raphaelites' works of social commentary can be found in Millais' moving work The Blind Girl in which a blind beggar girl is depicted near Winchelsea with another little girl holding on to her.

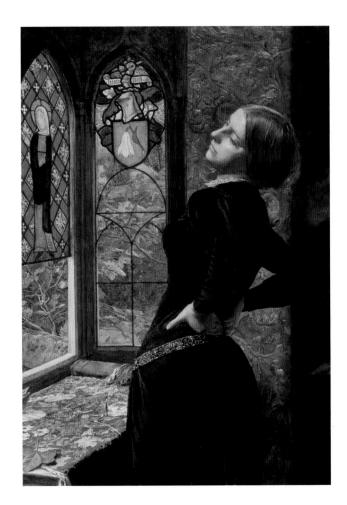

The Role of Women

In Victorian Britain, women were second-class citizens with rights similar to those of children. They did not have the right to vote, could not sue and were prohibited from owning property or possessing a bank account. Make-up was frowned upon and chasteness and purity were all. Clothing was not permitted to be tight, and not an inch of flesh was to be shown. They were not allowed to work, unless as a teacher or domestic servant. Their role was, in fact, simply to bear children and look after the house, to be, as Isabella Beeton (1836–65) said in her classic Victorian housekeeping manual, Mrs Beeton's Book of Household Management, a 'Household General'.

Women as the Victim

Prostitution was endemic in the towns and cities of Victorian Britain. Although prostitutes were regarded as unclean, it was considered natural for a man to want to use the services of a prostitute. Women destroyed by love – whether by false promises, tragic love or unrequited love – is a common theme in not just Pre-Raphaelite art but also in Victorian art in general. For the Pre-Raphaelites, however, the woman was often seen as the victim, a recurring motif, of course, of medieval romance. Generally speaking, in Victorian art, the woman is depicted on her own, cast out into the world because of sexual

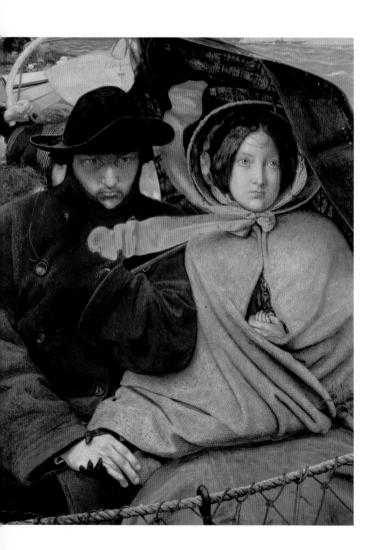

transgressions for which she, and not the man, takes the blame. The Pre-Raphaelites often included the male in the picture – as was the case with Hunt's *The Awakening Conscience* – or at least made reference to his role in some way. She becomes, therefore, a person who has been wronged and the question is begged as to who is responsible.

In Millais' *Mariana* (see previous page and page 51), the female subject of the picture is shown stretching sensuously before a stained glass window, her hands somewhat provocatively on the back of her hips. The picture depicts a woman waiting in vain for her lover but Millais dispenses with the traditional representation of a woman grieving. She is separated from the natural world outside, the world of passion and human contact and the changing leaves outside her window and on the table in front of her suggest that she too is withering away as she waits longingly for his return. Thus, Millais presents *Mariana* to the viewer as a real woman with emotions and desires.

The British Empire

Until the nineteenth century, the British Empire had been a mercantile one, the purpose of which was to acquire foreign territory as a source of raw materials and to provide markets for British exports. At the end of the Napoleonic Wars, however, Britain was in a fortuitous position, its rivals having lost their empires or seen them diminish. Not only that, but the Industrial Revolution had made the country Europe's leading industrialized nation. With its powerful navy ruling the waves around the world, more and more territory came under British control and for the next century – Britain's 'Imperial Century' – Britain would occupy a dominant position in the world and continue to expand its territories. During that time, around 26 million square km (10 million square miles) and 400 million people were added to the empire, making it the largest formal empire that the world has ever known. Britain became a 'global policeman', leading to a situation known as the 'Pax Britanica', when unchallenged British sea power controlled most of the

maritime trade routes. It was against such a background that the Pre-Raphaelites worked, defining the culture of a nation that truly did, as the song says, 'rule the waves'.

The Printing Press

At the start of the Industrial Revolution, the printing press had remained relatively unchanged since its invention by Johannes Gutenberg in around 1440. Gradually, new materials were introduced into its manufacture and by 1800, Lord Stanhope had built a press made from cast iron which reduced the force required to print a page by 90 per cent and also doubled the size of the printed area. It also doubled the production capacity of the old press, to 480 pages an hour.

Steam Power

- Steam power radically altered the design of the printing press, as did the introduction of rotary cylinders. The German printer Friedrich Koenig designed a press that could produce 1,100 pages per hour which he sold to *The Times* in 1814. It was an important step in making newspapers available to a mass audience.
- In the 1820s, it also began to change book production and in 1843, the steam powered rotary printing press was invented in the United States by Richard M. Hoe. This permitted the printing of millions of copies of a page in a single day. Rolled paper allowed a continuous feed and the mass production of printed works had arrived.

The Moxon Tennyson

These developments in printing undoubtedly helped the Pre-Raphaelites to make their works accessible to a greater audience than the one that was able to visit London art galleries. Book illustration flourished in the middle of the nineteenth century, helped by the new technology. John Ruskin used his considerable influence to persuade the poet, Alfred, Lord Tennyson (1809–92), to allow Hunt, Millais and Rossetti to illustrate his forthcoming

book of poems, published by Edward Moxon in 1857 and now known as The Moxon Tennyson. The results were remarkable and the work of the Pre-Raphaelites found an even wider audience.

Kelmscott Press

William Morris later took an interest in publishing, and particularly in typography. He published *The House of Wolfings* in 1889 under the Chiswick Press imprint. Shortly after, he established his own printing press, using the name the Kelmscott Press, publishing an acknowledged masterpiece of book design, *The Works of Geoffrey Chaucer*, also known as *The Kelmscott Chaucer*, in 1896, its 87 illustrations created by Edward Burne-Jones.

Places

NUMBER OF PLACES BECAME important, to and associated with the PRB, either through where they lived or found inspiration to paint. Because of one of their principle aims was to study nature attentively, many of the works were either executed outside or showed great attention to their surroundings, whether that be landscape, flowers and foliage or light and shade.

London

- The riches of empire and the rise of industry made London a city of clashing contradictions. New building went hand-in-hand with abject squalor, people crowded into slums with no sanitation. In 1800, the city's population was one million, but by the end of the nineteenth century, it had risen to more than six million. The air of the city was horrific, the widespread use of coal and lack of sanitation making a stroll in its streets a heady experience. Raw sewage was pumped straight into the Thames until Joseph Bazalgette built more than 2,000 km (1,2000 miles) of tunnels and pipes to take sewage out of the city. The result was not only a cleaner river, but also a reduction in the death rate from the frequent cholera outbreaks.
- Rossetti was born in London, Hunt in Ewell, Surrey, and Millais was from a Jersey family, although he was born in Southampton. However, the three met as students at the Royal Academy Schools in the capital and spent much of the remainder of their lives living and working there.
- A number of places in the city would become important to the Pre-Raphaelites, especially Cleveland Street where, at the beginning of Pre-Raphaelitism, Hunt and Rossetti had a studio and Gower Street where Millais worked in a converted greenhouse at the back of his house.

The Holy Land

Academy and while Rossetti was preoccupied with Lizzie Siddal, William Holman Hunt was getting ready to leave England. He had decided to relocate to the Holy Land, a bold, although logical move for him. However, it cut him off from the artistic milieu and from his Pre-Raphaelite brothers, in particular. He had become obsessive about his religious beliefs which would certainly go some way towards explaining the strangest of all

Pre-Raphaelite paintings, the wildly uncompromising and eccentric work, *The Scapegoat* (see right and page 71), which he painted during his first visit to the Holy Land.

Setting out for Palestine

Hunt had been planning to make the trip for some time. He had discussed it with a number of friends, including Millais and Rossetti, the artist and writer Edward Lear, the art collector Thomas Combe, the traveller and archaeologist Austin Layard and the painter Augustus Egg. Many of them advised Hunt against the trip, warning him of the dangers, but he was not to be dissuaded. He firmly believed that art should serve Christ, but he also believed that religious painting to date had been untruthful. He was convinced that the only way to paint the life of Christ truthfully was to actually do it in situ, in the very places in which events took place. He wanted, as he said, to 'use my powers to make more tangible Jesus Christ's history and teaching'. Therefore, against the advice of all – he suddenly brought his affairs in London to a close and set out for Palestine. It would be the first of four trips he made to the Holy Land.

Notable Works

- He rented a studio in Jerusalem and was immediately delighted by the exotic nature of his surroundings. In summer and autumn 1854, he worked on two important paintings – The Finding of the Saviour in the Temple (see page 72), a work replete with lavish oriental motifs, and *The Scapegoat*. The latter work was unprecedented, inspired by the Talmudic practice of driving a scapegoat into the wilderness that takes with it all of the people's sins. Hunt painted a white goat beside the Dead Sea, in an ugly spot blighted by saline deposits and the skeletons of dead animals. The painting was sent back to England where it was greeted with consternation by critics and public alike. Writing in his diary, however, Ford Madox Brown said of it, 'Hunt's scapegoat requires to be seen to be believed in. Only then can it be understood how...out of an old goat, and some saline encrustations, can be made one of the most tragic and impressive works in the annals of art.' The Finding of the Saviour in the Temple, meanwhile, was highly praised and sold

for a considerable sum, the beginning of financial security for the artist bolstered by money he earned from the reproduction rights of his Palestine pictures.

Scotland

On Millais' infamous trip to the Scottish Highlands in summer 1853 during which he and Effie Ruskin fell in love and he began his portrait of John Ruskin, it appears Millais also fell in love with Perthshire. Throughout their marriage, he and Effie rented a house for three or four months every summer, breaks from London society during which he would enjoy deer stalking, shooting and salmon fishing but during which he would also create a remarkable series of landscapes that depicted the epic, elemental nature of the rugged Perthshire scenery and weather.

The Landscapes

Described by one commentator as 'the great dark horses of his career', nearly all of Millais' 21 great landscapes were painted within a few miles of Birnam and Dunkeld. They are mostly bleak hymns to the power and transience of nature, such as his 1870

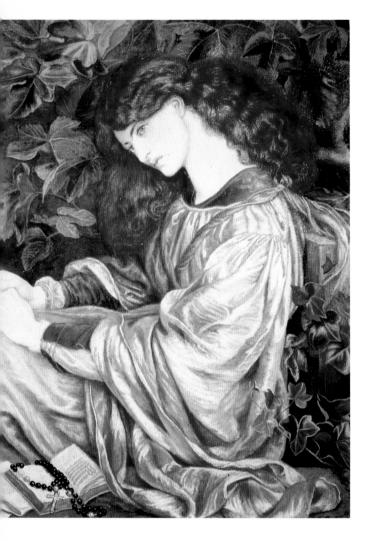

work, *Chill October* which set the standard with its melancholy mood and bravura depiction of the dramatic Scottish weather. He would later say that 'there is more significance and feeling in one day of a Scotch autumn than in a whole half-year of spring and summer in Italy'.

On a Grand Scale

One of the finest of these landscapes is the 1876 painting, *The Sound of Many Waters*, a dramatic view of the Rumbling Bridge Falls near Dunkeld that Millais described to Effie as 'a beautiful scene of rushing water between rocks and autumn foliage forming a crescent above... It is a diabolical subject as it

is so full of detail'. William Michael Rossetti wrote how 'a large abundance of striking material is treated with masterly energy and ease: all comes so well together as to produce an effect almost of simplicity, though in fact the subject is extremely complex'. He went on to describe it as 'the finest landscape yet exhibited by Mr Millais'.

These pictures were all on an appropriately large scale, around 1.8 x 1.2 metres (6 x 4 feet) and show the artist responding in his own way to the new type of landscape painting that was evolving across the Channel, although his approach was far removed from that of the Impressionists. He did not seek to depict the transitory effects of light on nature, but, rather, painted exactly what he saw in front of him, remaining true to Pre-Raphaelite principles.

Italy

- The Pre-Raphaelites were besotted with Italy. The country's art, history, literature and landscape provided an endless source of inspiration for their work. Even their name reflects this love of everything Italian, focusing, as it does, on Italian art before Raphael.
- At the beginning of the PRB, their knowledge of early Italian art was limited to the engravings by the Florentine engraver, Carlo Lasinio (1759–1838) of the frescoes in the Camposanto at Pisa. They did not travel to Italy to study and could not afford to embark on a Grand Tour.

Italian Inspiration

His father being Italian, Rossetti, of course, had particular reason to be interested in Italy, although he never travelled there. Rossetti loved the notion of Italy so much, in fact, that he swapped his names around – having been born Gabriel Dante Rossetti – so that he would share the name of Italy's great national poet. He translated Dante's works from an early age and painted a number of scenes from the poet's 'The Divine Comedy' and 'La Vita Nuova' such as in La Pia de' Jolomei

(see left and page 112) and *Beata Beatrix*. Throughout the 1860s and 1870s, he sometimes arranged the subjects of his portraits in poses suggested by lines from Dante.

Italian Cities

Millais and his wife travelled to Italy as tourists in 1865 and Hunt spent time in Florence and Naples between 1866 and 1868 when a visit to the Holy Land was delayed due to quarantine restrictions. John Ruskin, on the other hand, spent a great deal of time in Italy, first travelling there aged 14 and often wintering in Venice. His study of the country's art and architecture was fundamental to his thinking. In 1845, when he explored Tuscany and Venice in preparation for the second volume of *Modern Painters*, he discovered the art of Fra Angelico (c. 1395–1455) and Tintoretto (1518–94), and his winters in Venice in 1849–50 and 1851–52 helped him to write his book *The Stones of Venice*. Later in life, he sometimes travelled with friends and pupils, such as Edward and Georgiana Burne-Jones with whom he voyaged to Italy in 1862.

The American Church, Rome

Burne-Jones visited Italy four times, studying the work of artists virtually unknown in Britain, such as Vittore Carpaccio (*c*. 1465–1525/1526). His designs for the mosaics in the American Church in Rome – reckoned by some to be the greatest of all Pre-Raphaelite decorative schemes – preoccupied him from 1881 until his death in 1898.

Val d'Aosta

In the 1850s and 1860s, several Pre-Raphaelite artists created some of their most original works in Italy. One such was John Brett (1831–1902), a particular favourite of John Ruskin, who no doubt enjoyed Brett's attention to detail as well as his shared interest in geology. The two men travelled together to Val d'Aosta in the summer of 1858 from where Ruskin wrote goodhumouredly to Brett's father, explaining how he was tutoring his son. 'He is much tougher and stronger than Inchbold, [the artist John William Inchbold (1830–88)] and takes more hammering; but I think he looks more miserable every day, and

have good hope of making him more completely wretched in a day or two more...' The painting that emerged from the trip was the strangely haunting *Val d'Aosta* (*see* below and page 88). Ruskin said of it, 'for the first time in history, we have by help of art, the power of visiting a place, reasoning about it and knowing it, just as if it were there.'

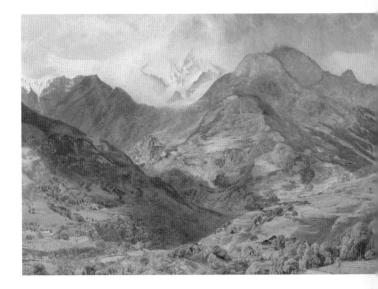

Sussex

- The light and variety and wildness of its landscapes attracted several of the Pre-Raphaelites to the seaside town of Hastings, particularly Dante Gabriel Rossetti. The town also became a favourite of Rossetti's muse and future wife, Lizzie Siddal, who travelled frequently to Hastings for a change of air and to recover from illness. For years, Rossetti had refused to marry Lizzie and she finally broke off their engagement in 1858. By this time, too, she was being replaced as his model by Annie Miller (1835–1925), Ruth Herbert (1831–1921) and Jane Burden. It was around this time that she became addicted to laudanum.
- Ruskin effected a reconciliation between her and Rossetti, and on 23 May 1860 he finally married her in St Clements Church in Hastings. Sadly, however, she died just two years later from an overdose of laudanum.

Winchelsea

Pre-Raphaelites was Winchelsea. Ruskin's hero, Turner had sketched and painted extensively in the area and Rossetti visited in 1866, noting the 'pleasant doziness' of the town. A regular visitor to Winchelsea was John Everett Millais who had been introduced to the area by Edward Lear. It was there in 1854 that Millais painted his famous painting The Blind Girl in which the subject of the painting is shown against the background of Strand Hill, Kent.

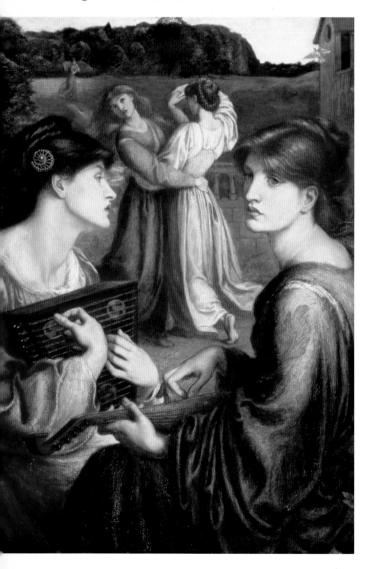

Kent

In autumn 1850, Rossetti travelled to Knole Park, Sevenoaks, where Hunt and Frederic Stephens were working. Rossetti failed to finish his painting but would use the landscape already on the unfinished canvas in October 1871 to paint The Bower Meadow (see left and page 124). Arthur Hughes lived and worked in Maidstone in Kent and his famous painting April Love (see page 66), a study of the transient nature of young love, was at least partially painted in a garden in the town.

The Red House

design the Red House in Bexleyheath, Kent in 1859. It is an enormously significant building in the history of British architecture and garden design and to it he added paintings and stained glass by Dante Gabriel Rossetti and Edward Burne-Jones. It was described by Rossetti as 'a most noble work in every way, and more a poem than a house...but an admirable place to live in too'. The Pre-Raphaelites had many enjoyable times there until Morris was forced to sell it after five years.

Surrey

- The expansion of the railways from 800 km (500 miles) of track in 1838 to more than 13,000 km (8,000 miles) by 1855 made a significant impact on the Pre-Raphaelites who were now able to travel into the countryside to work in the open air. Some of their earliest forays were into the Surrey countryside which had been rendered accessible by the extension of the London and Brighton railway in 1847. Millais and Hunt made landscape studies in Ewell in Surrey. These landscapes form the backgrounds to two very famous pictures: Millais' *Ophelia* (see page 55) and Hunt's *The Hireling Shepherd* (see page 53).
- Hunt's *Valentine Rescuing Sylvia from Proteus* (see page 54) is similarly painted in the Surrey countryside where he was eager to work in the natural light.

Oxford

The university city of Oxford played an important role in the Pre-Raphaelite Brotherhood. Millais first went to the town in 1846 when he was just 16. Visiting his brother, he met the Oxford art dealer, James Wyatt and it was there that in 1849 he met Thomas Combe, 'Printer to the University' at Oxford University Press who had commissioned him to paint portraits of his family. Combe and his wife were keen patrons of the arts and in particular of the Pre-Raphaelites. Following his death, his wife continued to collect Pre-Raphaelite works and when she died, the collection was bequeathed to the Ashmolean Museum in Oxford.

Morris and Burne-Jones

william Morris, in particular, was shaped by Oxford, a city that retained the charms that had been lost in many other places blighted by rapid industrialization. Morris and Edward Burne-Jones met at Oxford University where they discovered that they shared similar tastes, admiring Tennyson, Keats, Shelley and Carlyle. They discovered Sir Thomas Malory's Le Morte & Arthur and studied medieval romance. Remarkably, they knew nothing of the Pre-Raphaelites but Burne-Jones eventually met Rossetti in Oxford and then visited his studio. Under the older artist's influence, he began to paint. Morris, meanwhile, remained in Oxford, training to be an architect. When the firm he was working for moved to London, Morris and Burne-Jones moved into rooms in Red Lion Square previously occupied by Rossetti and Walter Deverell.

Le Morte d'Arthur

In the spring and summer of 1857, Oxford played host to one of the most enjoyable projects in Pre-Raphaelite history. Rossetti persuaded Benjamin Woodward (1816–61), the Irish architect who had been engaged to build a new debating hall for the Oxford Union, to allow him and his associates to decorate the debating hall. He summoned Morris and Burne-Jones from London and also engaged John Hungerford Pollen (1820–1902), Arthur Hughes, Val Prinsep (1838–1904) and John Roddam Spencer Stanhope. They had enormous fun working together to

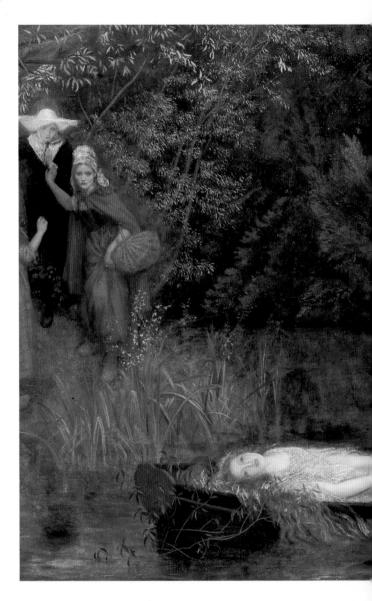

create 10 murals illustrating $\ensuremath{\textit{Le Morte d'Arthur}}$. Sadly, they had not fully grasped the technique of fresco, and the murals they created soon peeled off.

Kelmscott Manor

Morris went on to live in the sixteenth-century Kelmscott Manor in Oxfordshire, drawing inspiration from the authenticity of its architecture. He named the private press that he founded the Kelmscott Press after the house.

Styles & Techniques

RT AT THE TIME OF THE PRB HAD become, rather unimaginative and artificial. Millais, Hunt and Rossetti set out to revitalize English painting by moving towards the use of bright colours, by observing and accurately re-creating nature, by portraying simple rather than grand subjects and by ensuring that they express and moral seriousness and sincerity in their work.

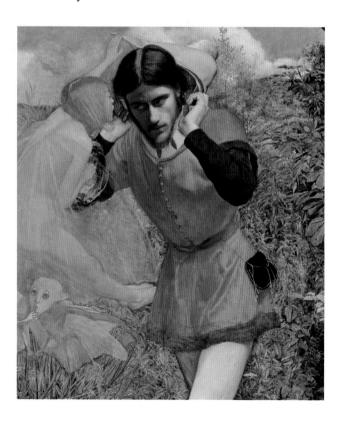

Brilliant Colour

- The art that was encouraged and taught by the Royal Academy was as unfailingly dark and ponderous as much of its subject matter. In fact, artists such as Sir Joshua Reynolds and Benjamin Haydon (1786–1846) used bitumen to deliberately create areas of murky darkness in their paintings. Remarkably, in order to satisfy the requirements of the prevailing taste, Old Masters were even doctored to make them darker.
- Some artists working before the Pre-Raphaelites had lightened their palettes. Turner had begun to paint lighter pictures, for instance, after a visit to Italy, and the painter William Mulready (1786–1863) was in the habit of painting colours thinly over a white ground.

Wet-white Technique

- The Pre-Raphaelites sought a revival of the brilliant colour that could be found in paintings of the quattrocento; in order to achieve this and give their colours a transparency and clarity, Hunt and Millais developed a technique which involved painting, like Mulready, in thin glazes of pigment over a wet, white ground. The 'wet-white' technique added brilliance and was claimed by Hunt to be especially effective 'for blossoms of flowers, for which it was singularly valuable, for sunlight on flesh and brilliantly lit drapery'.
- Hunt himself described the technique. 'Select a proposed ground originally for its brightness, and renovate it,' he wrote, 'if necessary, with fresh white when first it comes into the studio, the white to be mixed with a very little amber or copal varnish. Let this last coat become of a thoroughly stone-like hardness. Upon this surface, complete with exactness the outline of the part in hand (i.e. draw in pencil the part of the picture you are about to work on). 'On the morning for the painting, with fresh white paint, spread a further coat very evenly with a palette knife over the part for the day's work of such density that the drawing should faintly show through. Over this wet ground, the colour (transparent and

semi-transparent) should be laid with light subtle brushes and the touches must be made so tenderly that the ground below shall not be worked up.'

Naturalism and Realism

John Ruskin said that artists should 'go to nature in all singleness of heart...rejecting nothing, selecting nothing and scorning nothing; believing in all things right and good, and rejoicing always in the truth.' For him, the truth of nature was the essence of all great art. The Pre-Raphaelites agreed, painting out of doors in all weathers in order to capture this truth.

Sunlight

The truth of what lay before them as they worked resulted in a further lightening of the tones of their works. Their paintings did not work on the notion, as espoused by the Academy, of a principal light. An Academy painting was organized so that the gaze is taken from darker tones towards the central light.

Ruskin's – and the Pre-Raphaelites' – answer to this was that the only lighting in which they were interested was that of the sun. One need only compare Hunt's *The Eve of St Agnes* (see page 39), painted just before the creation of the Pre-Raphaelite Brotherhood, with a work such as *The Hireling Shepherd* (see right and page 53) to understand the PRB's new approach to light.

Attention to Detail

- A fine example of the Pre-Raphaelite fidelity to nature can be found in Millais' beautiful painting *Autumn Leaves* (see page 80), in which he depicts four young girls collecting fallen leaves and putting them into a pile. One of them, the little girl at the front on the right is depicted with a slight squint, a blemish that went against correct academic standards but which was what the artist actually saw in front of him.
- One of the most striking elements of Pre-Raphaelite painting is, undoubtedly, this astonishing attention to detail both in nature

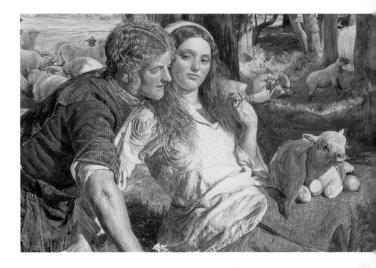

and in man-made items. They aspired to a photographic realism and faithfulness to nature that they believed would create a moral beauty and would depict the truth to the gaze of the viewer.

Principal Subjects and Themes

The Pre-Raphaelites were initially fascinated by medieval culture, although this would change in later years when Hunt and Millais moved away from medievalism towards realism. Hunt, however, could be said to have continued to focus on the spiritual significance of art, reconciling realism and religion by painting religious subjects in the Holy Land, in the places where the events of the Bible actually took place, as in *The Finding of the Saviour in the Temple* (see page 72). Rossetti led the avowedly medieval strand of Pre-Raphaelitism and in this he was supported by William Morris and Edward Burne-Jones. Morris's firm stimulated a great deal of interest in medieval designs and artwork.

Acceptable Subject Matter

The Pre-Raphaelites lacked the historical knowledge that John Ruskin possessed but in the beginning they created a list of 'immortals', as they called them, consisting of figures from

history who still had a relevance for the present; these were considered as sources fit for painting. It was a pyramid structure of five levels with Jesus Christ at the apex. Shakespeare and the author of the 'Book of Job' followed and on the third level were Homer, Dante, Chaucer, Leonardo, Goethe, Keats, Shelley, King Alfred, Landor, Thackeray, Washington and Browning. It was a strangely random list that is evidence of the movement's lack of intellectual cohesiveness. But, what they lacked in that area, they made up for in enthusiasm, passion and sheer skill.

Literary Sources

- Millais' first Pre-Raphaelite work, Jsabella (see page 40), drew from Keats's poem 'Isabella, or the Pot of Basil' and fulfils all the strictures of the new style: it is true to nature and has a directness and freshness about it. The portraiture is magnificent and the characterization is superb, especially in the malevolent demeanour of the two brothers who, in Keats's story, later murder the young lover of their sister, Isabella.
- Hunt, too, chose a literary source for his first Pre-Raphaelite painting. *Rienzi Vowing to Obtain Justice for the Death of his Young Brother, Slain in a Skirmish between the Colonna and the Orsini Factions* (see below and page 44) illustrates an episode in Edward Bulwer Lytton's novel 1835 *Rienzi*. Rossetti,

meanwhile, chose a religious subject for his first PRB work, The Girlhood of Mary Virgin, an appropriate subject for a painting executed in a strictly quattrocento style. Rossetti would later specialize in painting beautiful, soulful maidens who symbolized his romantic themes, many of them featuring his wife, Lizzie Siddal, Jane Burden, wife of William Morris or Alexa Wilding, who can be seen in his illustration of his own poem, the painting The Blessed Damozel (see page 122). Rossetti, in particular, became obsessed with painting women later in his career, the idea of the femme fatale fixed in his head. His depictions are of a fantasy woman, an object of worship. The sensually erotic Astarte Syriaca (see page 133), painted in 1877, showing William Morris's wife, Jane, as the Syrian love goddess, is a fine example.

Arthurian Legend

Arthurian legend held a particular fascination for Edward
Burne-Jones as can be seen in paintings such as *The Beguiling*of *Merlin* (see page 128). The scene is taken from the French
medieval *Romance of Merlin* and reflects Burne-Jones's ideas
of love, power and betrayal, as Nimue, the Lady of the Lake,
stands over the defenceless Merlin, enchanting him.

The Female Muse

She has become a cliché – the flame-haired, pale-skinned Pre-Raphaelite beauty with her thick neck, long jaw, faintly masculine features, aquiline nose and sensual gaze. Several of the beautiful women in the world of the Pre-Raphaelites have become famous. Rossetti called them 'stunners' and that was how his fellow artists also came to describe them. A number became their lovers or wives and their names have lived on – Elizabeth Siddal, Georgie Burne-Jones (1840–1920), Jane Morris, Fanny Cornforth, Maria Zambaco (1843–1914), Emma Madox Brown, Annie Miller, Euphemia (Effie Gray) Millais and Edith Holman Hunt.

Lizzie Siddal

Rossetti fell in love with the ultimate Pre-Raphaelite beauty: his model, Lizzie Siddal, known to the Pre-Raphaelites as 'Guggums'.

She had been Millais' model for *Ophelia* but Rossetti adored her, guarding her jealously. He married her in 1860 but in 1862 she sadly died of an overdose of laudanum. William Michael Rossetti described Siddal as 'a most beautiful creature with an air between dignity and sweetness with something that exceeded modest self-respect and partook of disdainful reserve; tall, finely-formed with a lofty neck and regular yet somewhat uncommon features, greenish-blue unsparkling eyes, large perfect eyelids, brilliant complexion and a lavish heavy wealth of coppery golden hair'.

She featured in countless Pre-Raphaelite pictures and Rossetti used her constantly. She appears in *Dante Drawing an Angel on the First Anniversary of the Death of Beatrice* (see page 64) of 1853 and he would go on painting her, even after her death, most notably in *Beata Beatrix* (see right and page 99). In this painting, the flame-haired Siddal is pictured as Dante's Beatrice who sits, as if in a trance, as a bird – the messenger of death – drops a poppy, symbolizing remembrance, into her hands. Meanwhile, in the background, the poet Dante gazes at the figure of Love.

Jane Burden

Jane Morris, née Burden, had been spotted by Rossetti at the theatre in Oxford where she was sitting in the row behind him. Her striking, dark-haired beauty was immortalized in paintings such as Rossetti's *Proserpine* (see page 136)*, painted in 1874, showing her as the unwilling wife of a powerful god. In her hand is a pomegranate, symbolizing fertility. Rossetti became obsessed with Jane and the two shared a close relationship, although it is thought not to have been sexual. His obsession, plus his growing dependence on the drug chloral, led her to distance herself from him. She appears in William Morris's only known painting, *La *Belle *Jseult**, on which he wrote endearingly on the canvas, 'I cannot paint you, but I love you'.

Three Phases of Beauty

There is a theory that suggests there were three phases of pre-Raphaelite beauty. The first phase, represented by

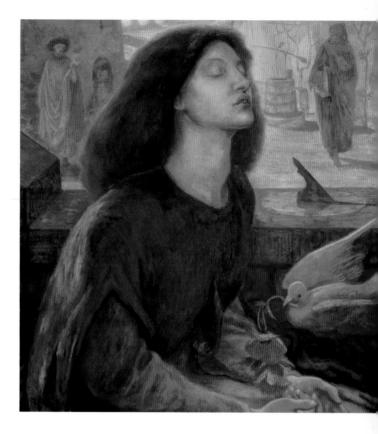

Elizabeth Siddal and perhaps Christina Rossetti who modelled for *The Girlhood of Mary Virgin*, features a demure, modest and innocent maiden. The second, as shown by the model Fanny Cornforth, a former prostitute who became Rossetti's mistress, features her as a much more sexual and carnal being. Cornforth featured in over 60 works by Rossetti, including *Bocca Baciata* ('lips that have been kissed', *see* page 91) of 1859 and *The Blue Bower* (*see* page 102) of 1865. The third phase of Pre-Raphaelite beauty featured the dark, enigmatic Jane Morris, as depicted in the 1869 work *Pandora* (*see* page 113) or the later *The Blessed Damozel* (*see* page 122).

Medievalism

The world, to the Pre-Raphaelites, had lost its innocence and its purity since the Renaissance. They looked back to a time before

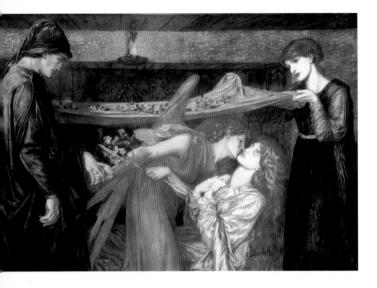

that, when there was more honesty in art and a greater spiritual and moral clarity, both in subject matter and painting technique. Romanticism, the artistic, literary and intellectual movement that had originated in Western Europe in the second half of the eighteenth century, had been a revival of the life and thought of the Middle Ages, a reaction to increasing industrialization, population growth and overcrowded cities.

The Nazarene Movement

The Pre-Raphaelite Brotherhood was strongly influenced by an early nineteenth-century group of German Romantic artists called the Nazarenes. The first effective anti-academic movement in European painting, they reacted against Neoclassicism and sought inspiration in the artists of the late Middle Ages in an effort to create an art that embodied spiritual values. Although they had disbanded by 1830, their medievalism would exert a major influence on the work of the Pre-Raphaelites.

Gothic Revival

Medievalism was also evident in the Gothic Revival that had begun in England in the 1740s. In the 1840s, Augustus Pugin designed important Gothic buildings such as the cathedrals at Southwark and Birmingham as well as the Palace of Westminster. Meanwhile, literature, too, espoused medievalism

- in the form of the Gothic novel, amongst which can be listed Mary Shelley's *Frankenstein* (1818), Emily Bronte's *Wuthering Heights* (1847) and Robert Louis Stevenson's *Dr Jekyll and Mr Hyde* (1886).
- The Pre-Raphaelite desire for a return to the simpler times and greater truth of the Middle Ages was, therefore, not entirely new but their popular, romantic version of it was striking and came to be emblematic of the entire movement.

Aestheticism

Aestheticism was a movement that was concerned with the appreciation of beauty in art and literature and rejected the idea that it should have a social or moral purpose: it was 'art for art's sake'. In doing so, it moved away from the notion of art espoused by John Ruskin or his fellow cultural critic, Matthew Arnold (1822–88), that art should be moral or useful. In Britain, it was influenced to a large extent by the writings of Oxford professor Walter Pater (1839–94). Aestheticists believed that art should not have a didactic purpose and that beauty was the basic desirable element of art. Ruskin's view of nature was also dispensed with; nature was chaotic and devoid of the design that could be created by art.

The English Aesthetics

William Morris and Edward Burne-Jones were central to the English Aesthetics movement. They had met Dante Gabriel Rossetti and fallen under his spell, being delighted with his passion for medieval scenes. When, in the 1860s, the Aesthetic movement began to gain ground, the second phase of Pre-Raphaelite painting became just one element of it. However, it pushed Pre-Raphaelitism into every aspect of British artistic life, as Morris developed his interests in the decorative arts and interior design. Design, in fact, came to play a major role in the paintings of Burne-Jones and even Morris in his only known painting, La Belle Jseult, shows an extraordinary interest in the wall hangings, rug and other textiles in the painting.

Burne-Jones the Aesthete

- Burne-Jones welded Pre-Raphaelite, Italianate and Classical elements together in an uniquely personal style but stayed true to the romantic tenets of Pre-Raphaelitism, still illustrating Arthurian legend until the end of his life and disabusing people of the notion that he was a leader of the Aesthetic movement. However, in a painting such as The Mirror of Venus (see below and page 140), it is not difficult to see the principles of Aestheticism at work. A group of beautiful maidens gaze into a pool of water against a background that resembles a lunar landscape, a feature often seen in his work; there is minimal narrative or historic content.
- Major exponents of Aestheticism were the poet Algernon Swinburne (1837–1909), the artist James McNeill Whistler, author and illustrator Aubrey Beardsley (1872–98) and Walter Pater.

Symbolism

The Symbolist movement had its origins in the publication of Les Fleurs du Mal by French poet Charles Baudelaire in 1857. Symbolists used symbolic images and indirect suggestion to express mystical ideas, emotions and states of mind. In its manifesto, published in 1886, Jean Moréas declared that Symbolists were against 'plain meanings, declamations, false sentimentality and matter-of-fact description'. Their aim was, rather, to 'clothe the Ideal in a perceptible form' whose 'goal was not in itself, but whose sole purpose was to express the Ideal'.

Symbolist Painting

In painting, Symbolism was a continuation of some elements of the Romantic tradition. Mythological or dream imagery was often used by the Symbolist artist and symbols were intensely private, personal and obscure. Symbolist painting would exert an influence on Art Nouveau and Les Nabis, the group of Post-Impressionist French artists.

Rossetti and Symbolism

Rossetti has always been seen as a precursor to Symbolism but, although their use was not central to the movement's ethos, Pre-Raphaelite paintings are replete with symbolic elements. Hunt's enigmatic painting The Scapegoat (see page 71) is perhaps the best example: the entire painting is symbolic. Hunt's The Awakening Conscience (see page 60) also features heavily symbolic elements. Even the wallpaper is symbolic, according to Hunt: 'The corn and the vine are left unguarded by the slumbering cupid watchers and the fruit is left to be preyed on by thievish birds.' Ruskin suggested that 'there is not a single object in all that room, common, modern, vulgar, but it becomes tragical, if rightly read'.

Not Forgotten

- Fashions change, and the Pre-Raphaelites fell out of fashion after the First World War, their idealistic depictions of medieval scenes at odds with the harsh realities of life in post-war Europe. In the 1960s, however, they entered the spotlight once again with a major revival of interest in their work.
- Finally, after decades in the wilderness, the works of Millais, Rossetti, Hunt and those who followed them were restored to their rightful place amongst the best-known and best-loved of all British paintings.

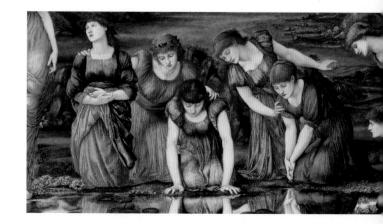

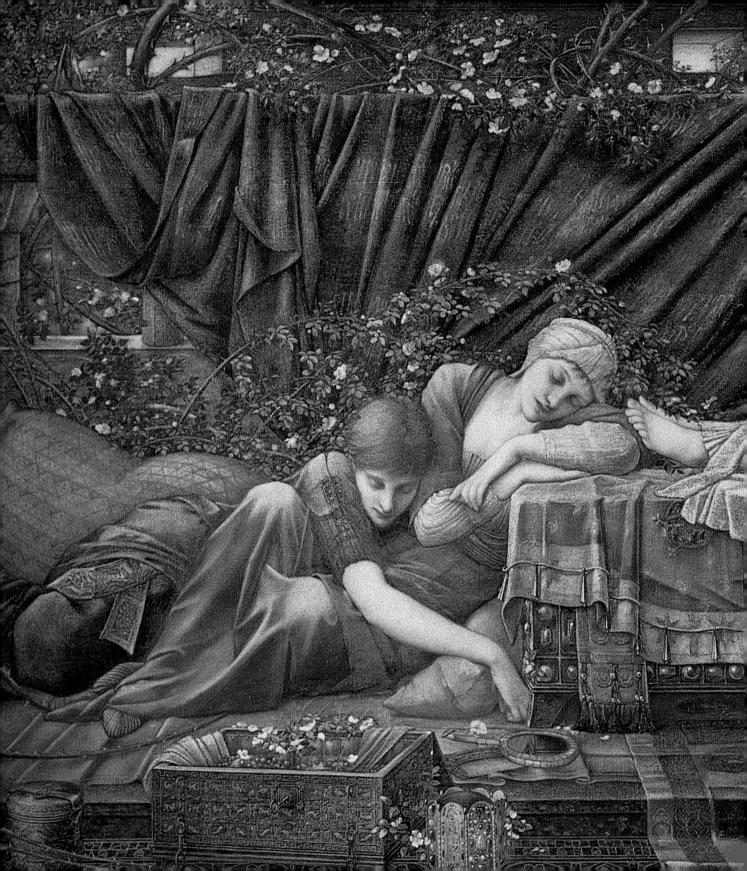

The Masterpieces

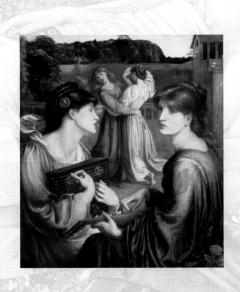

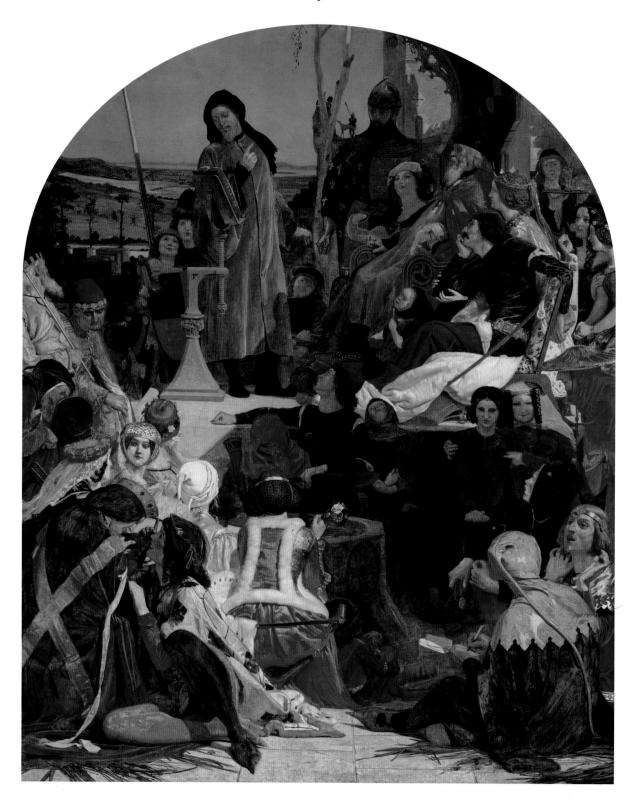

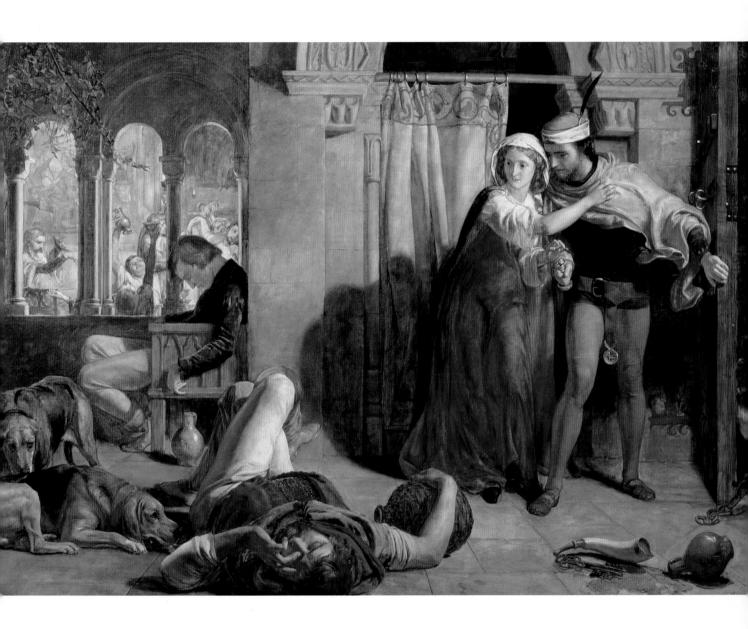

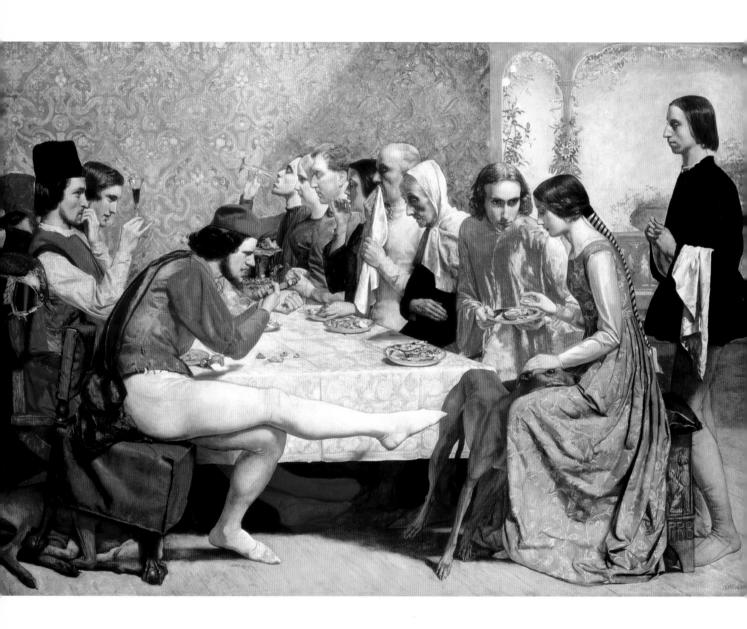

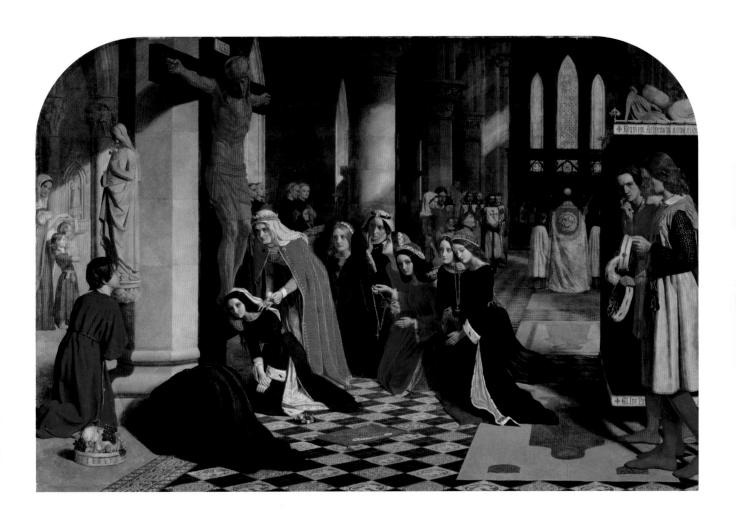

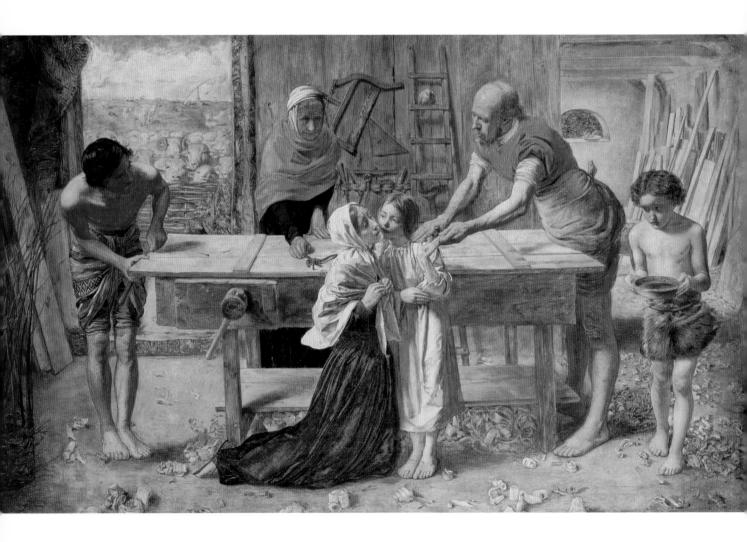

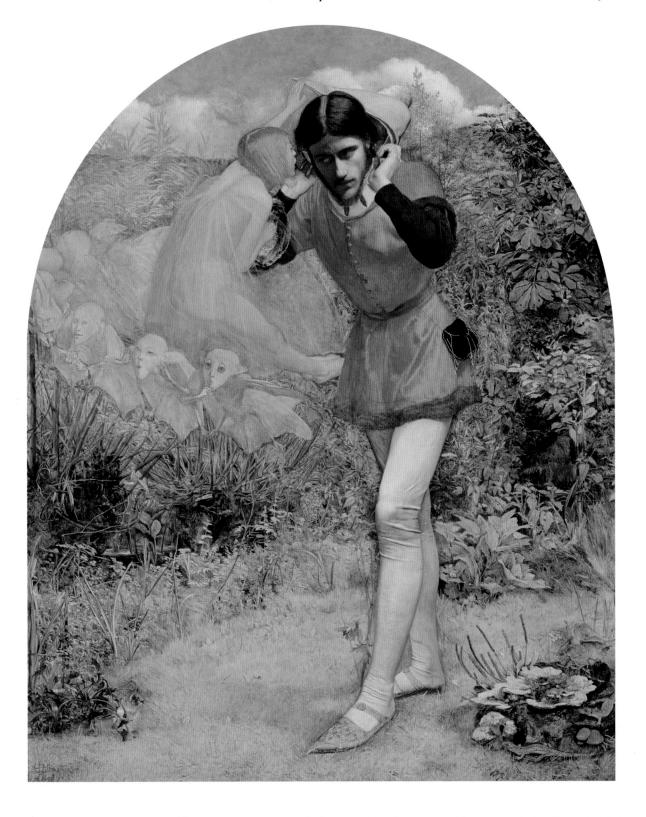

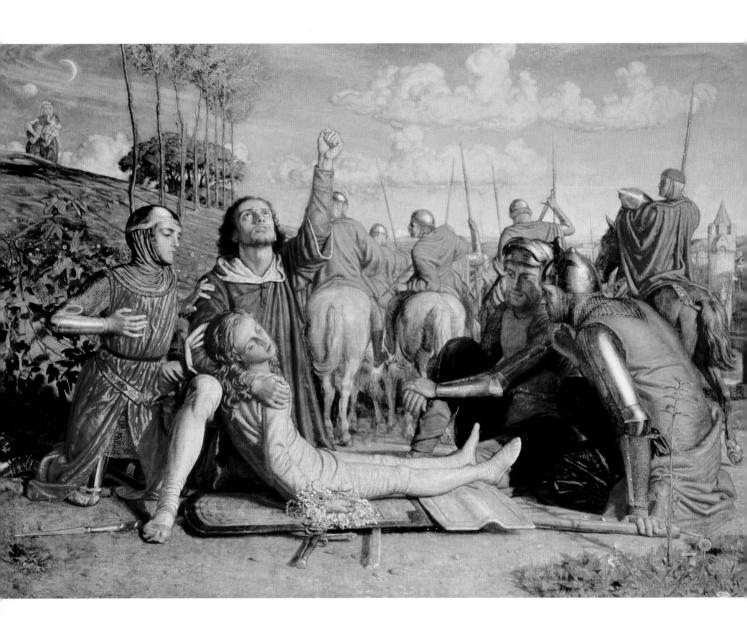

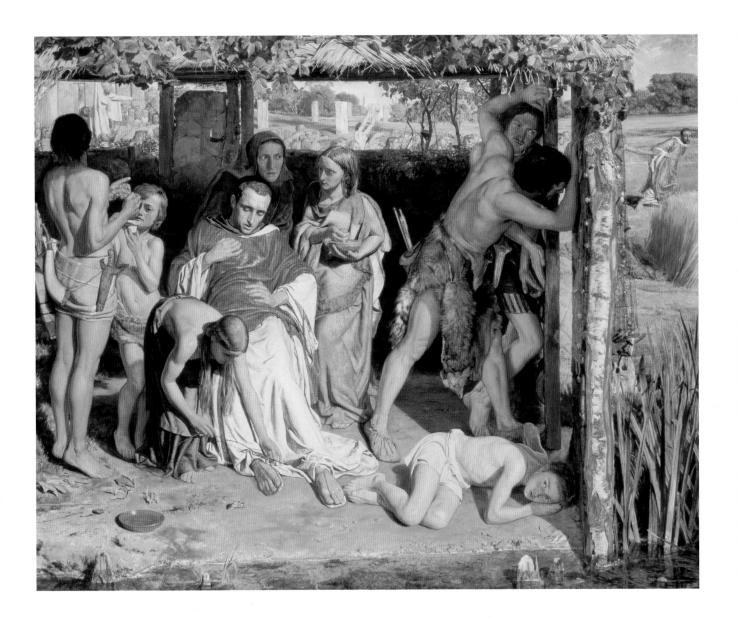

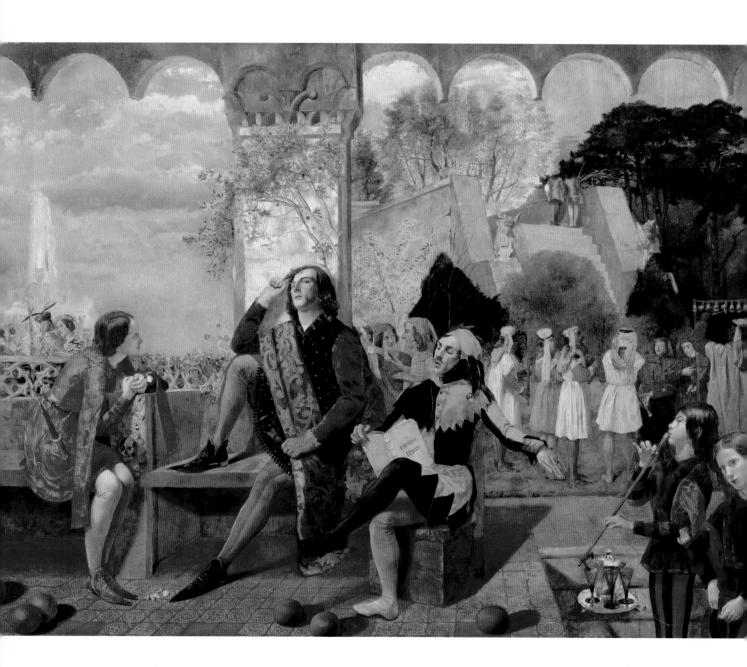

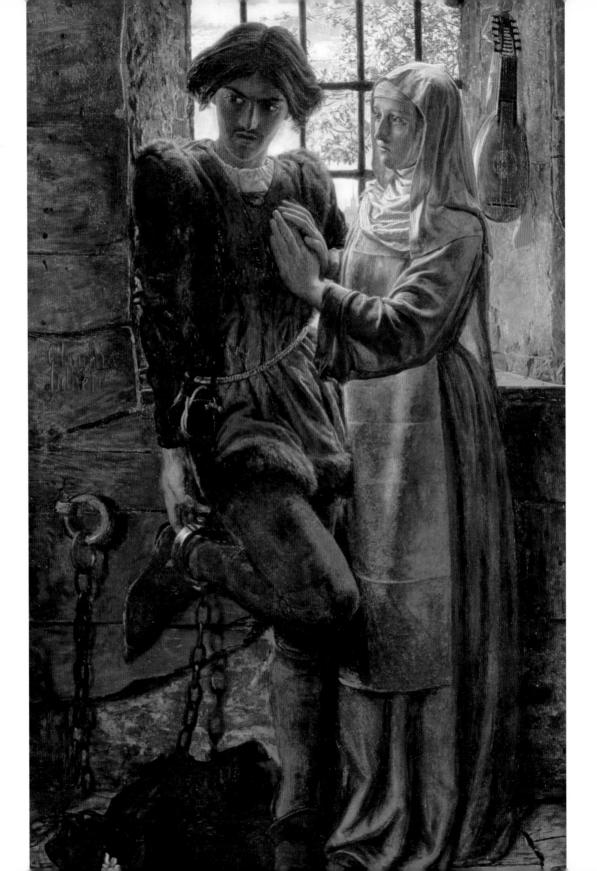

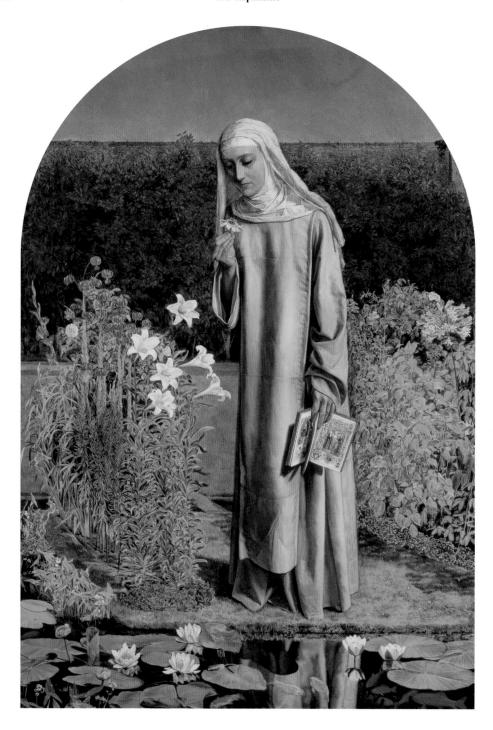

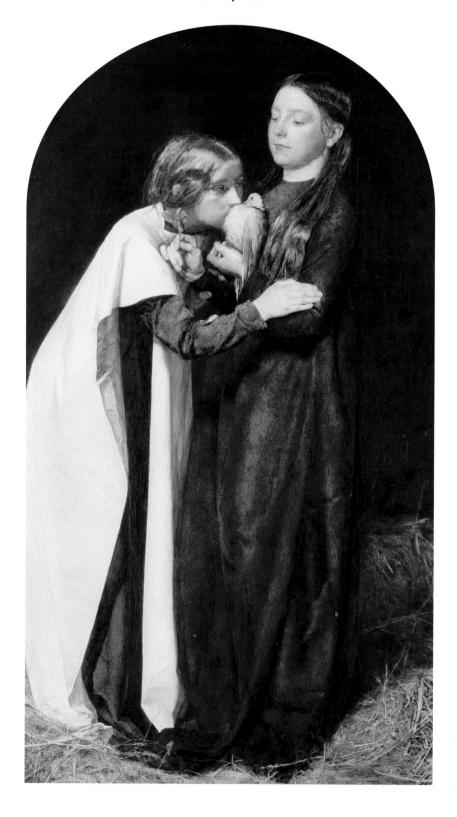

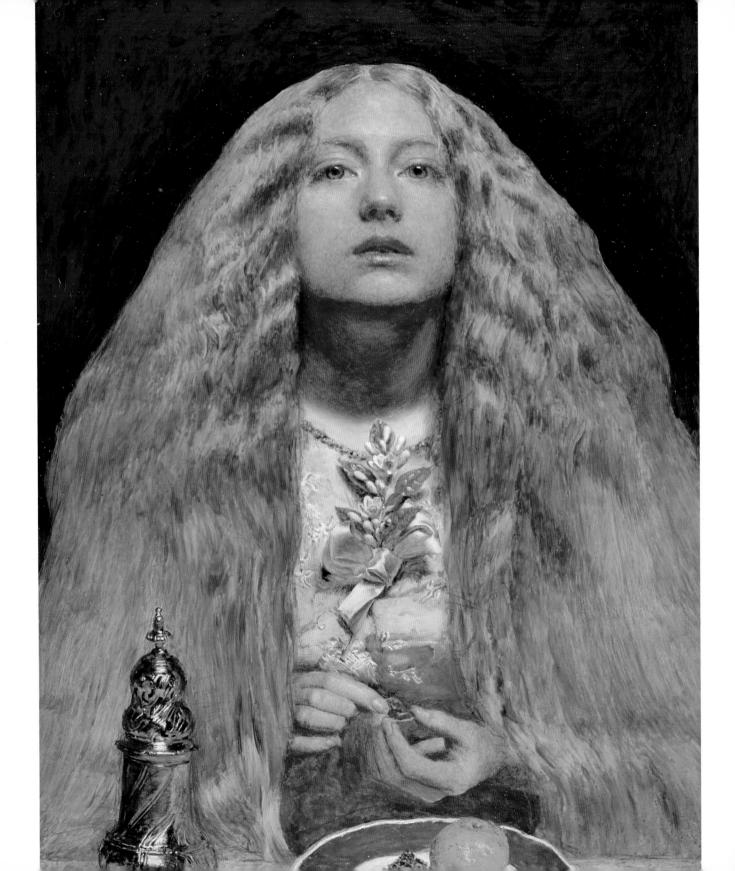

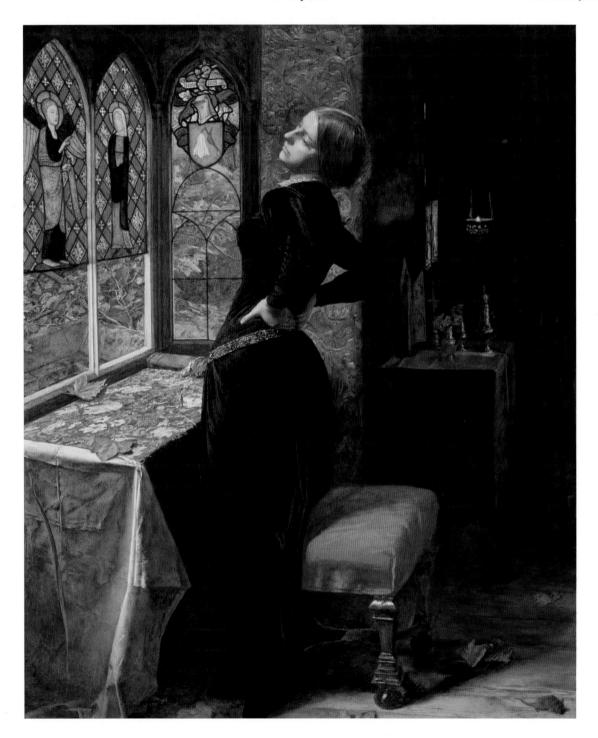

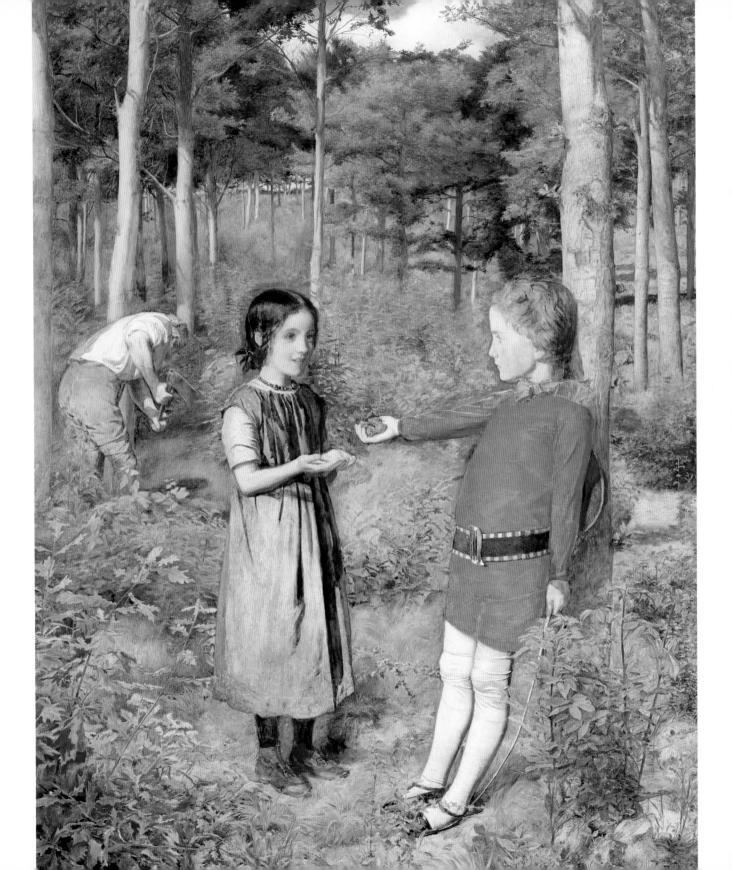

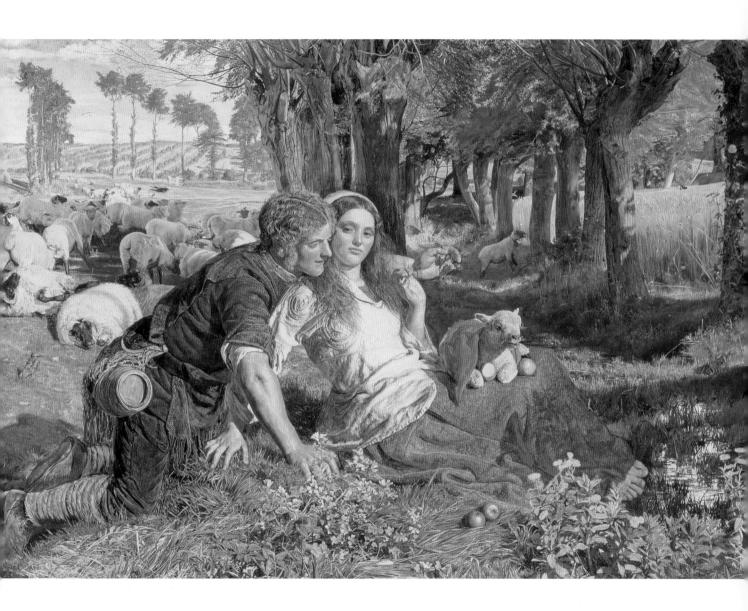

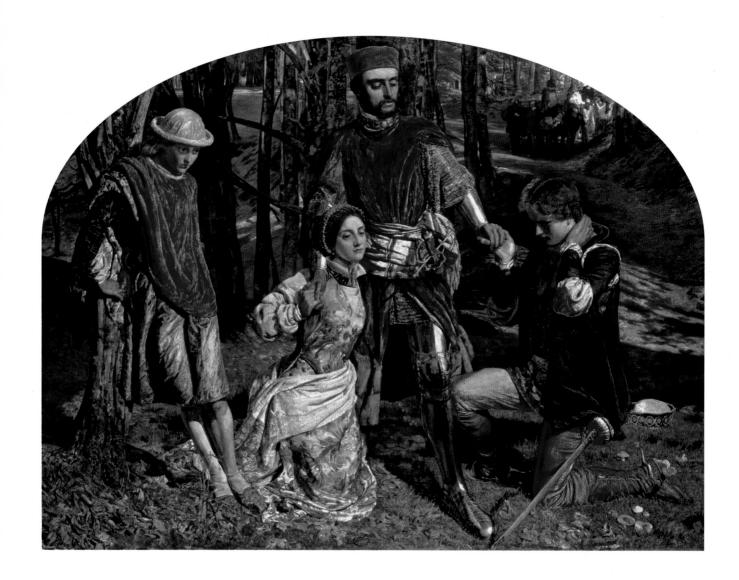

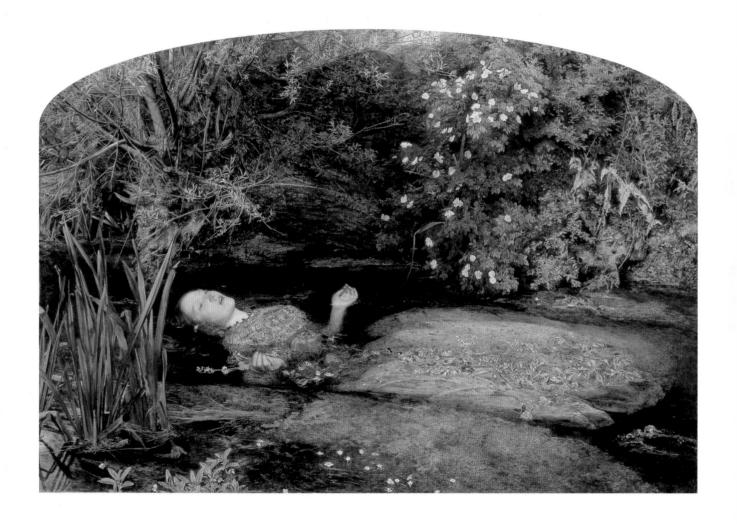

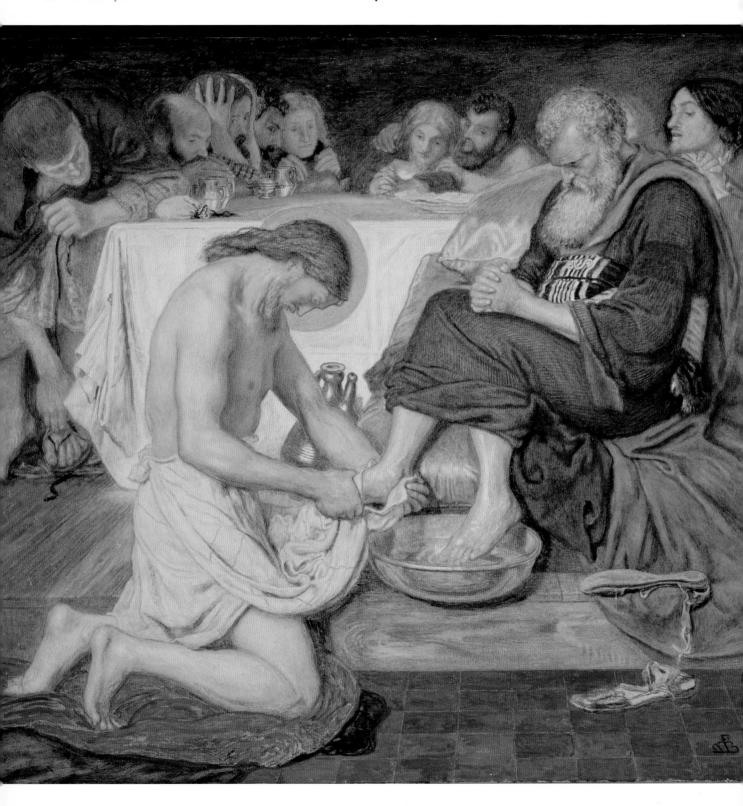

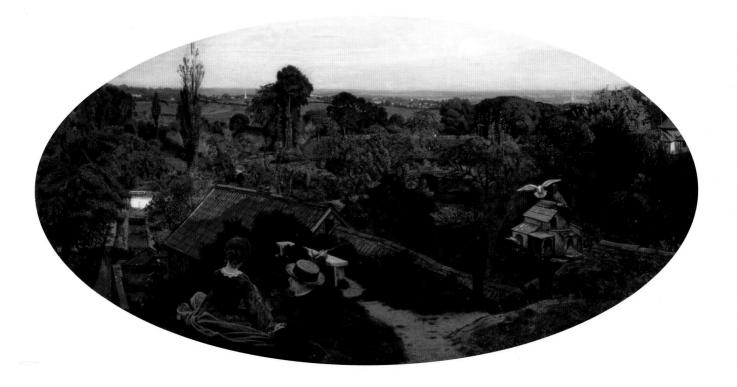

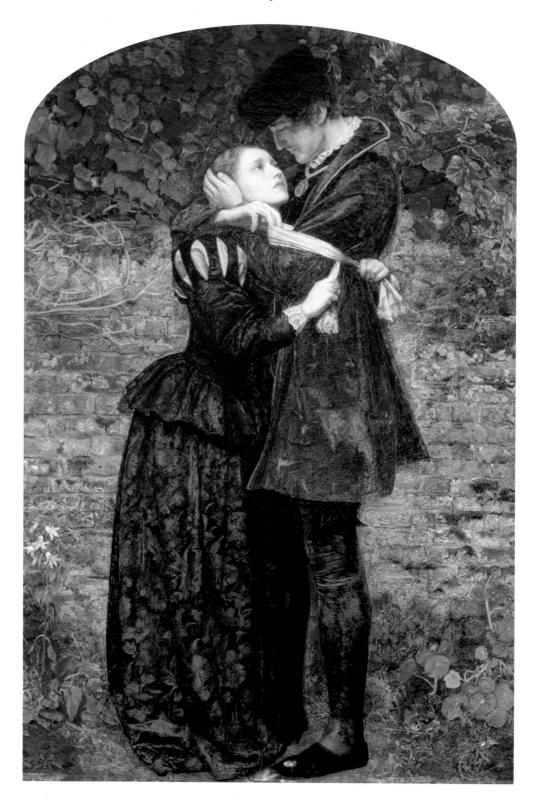

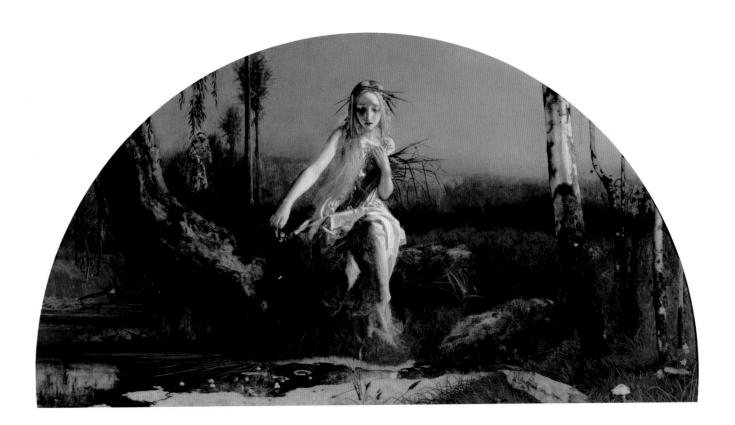

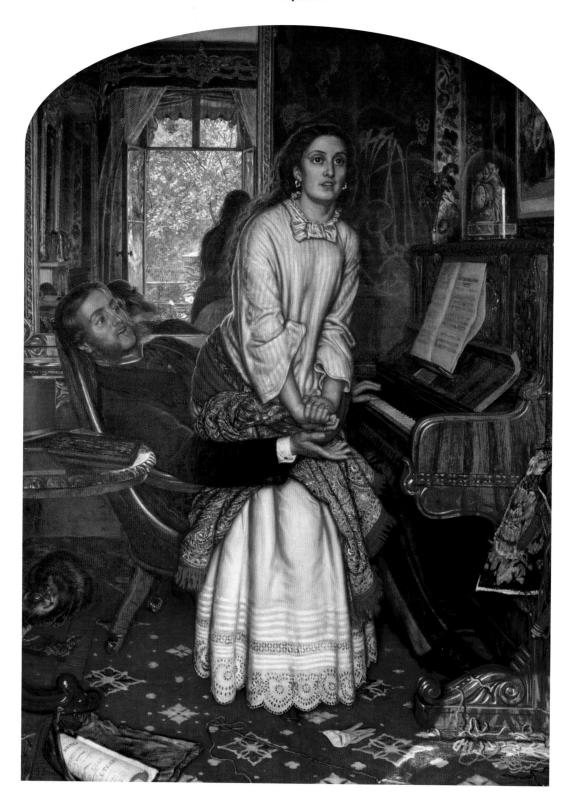

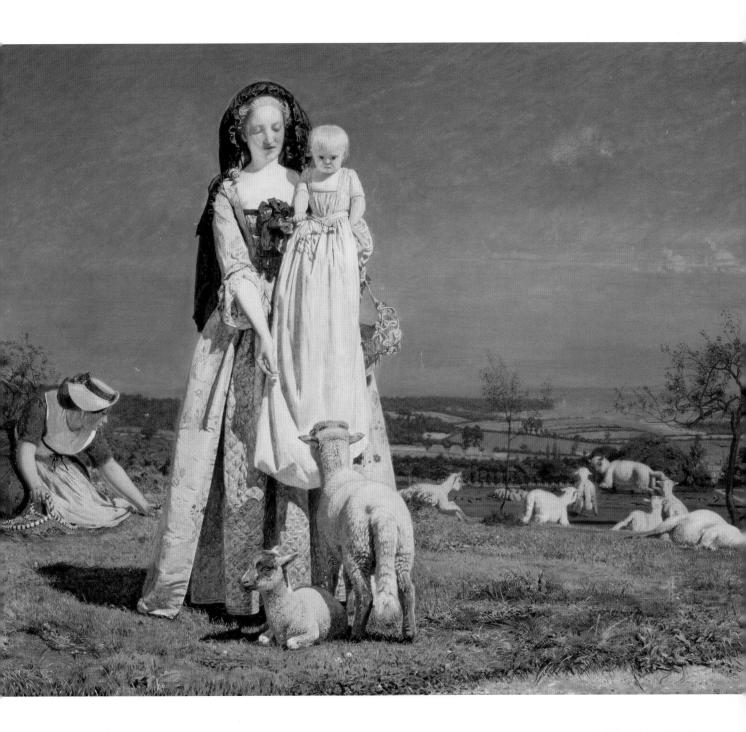

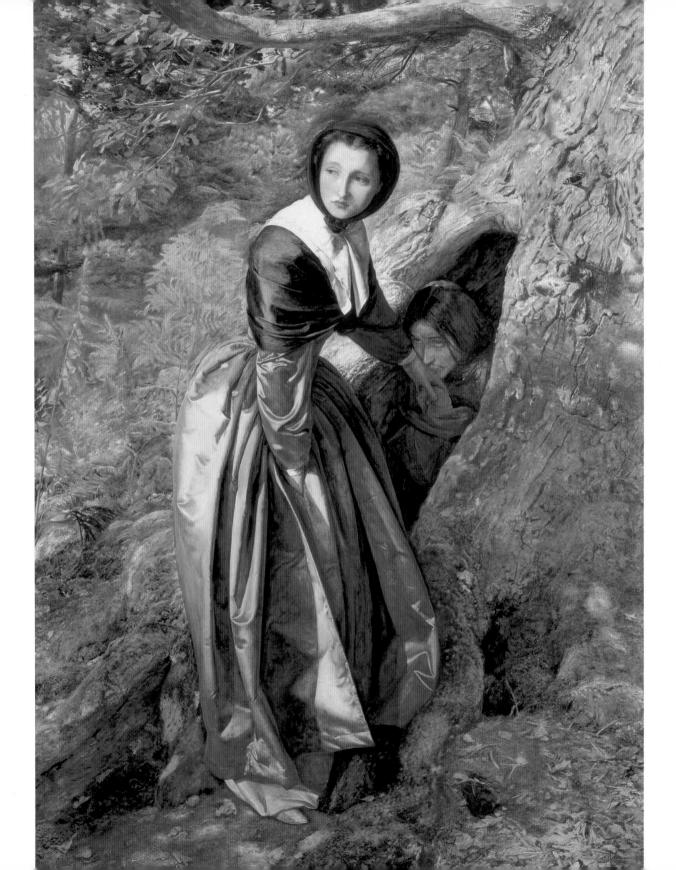

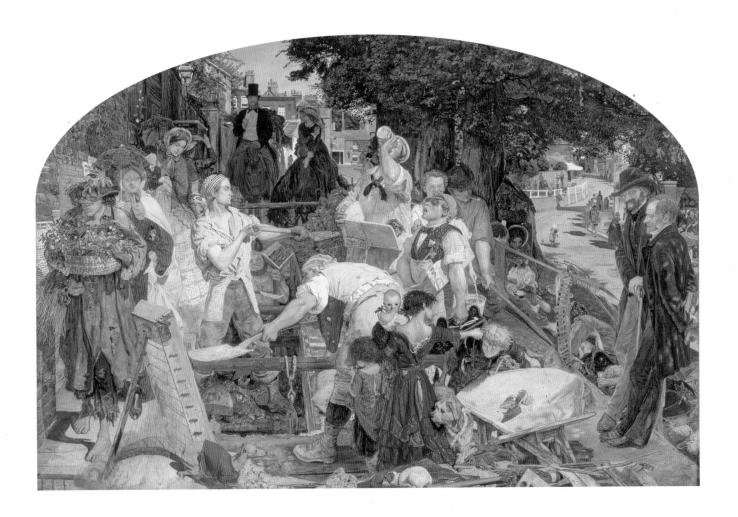

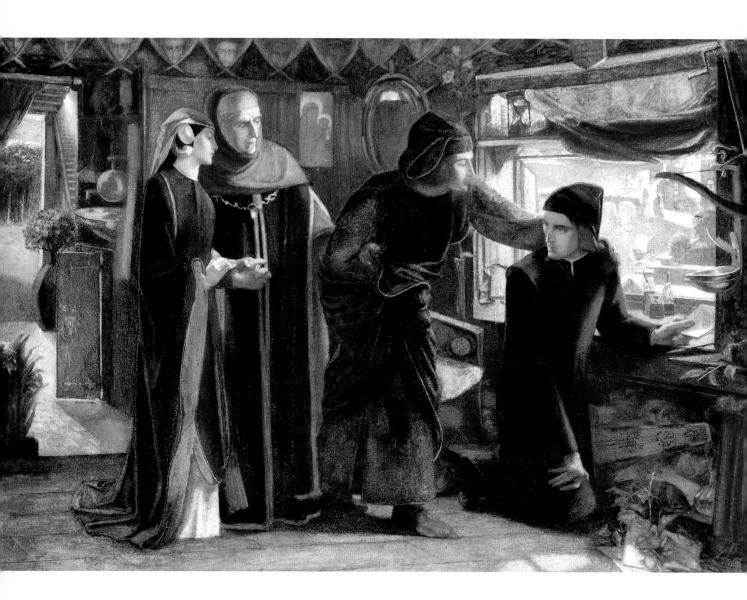

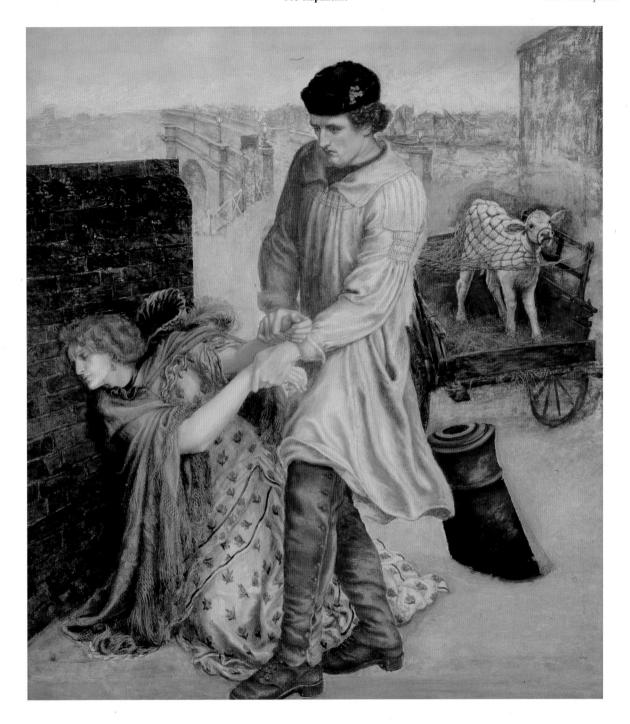

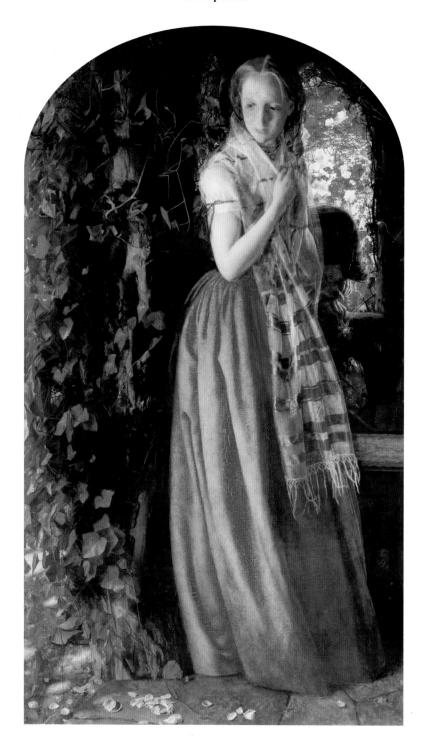

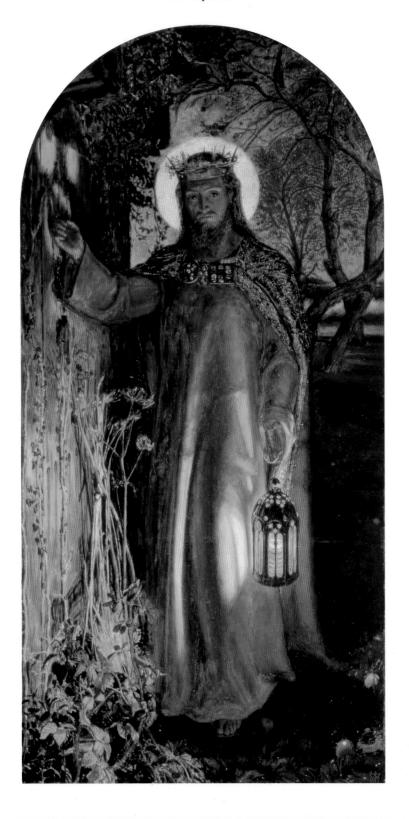

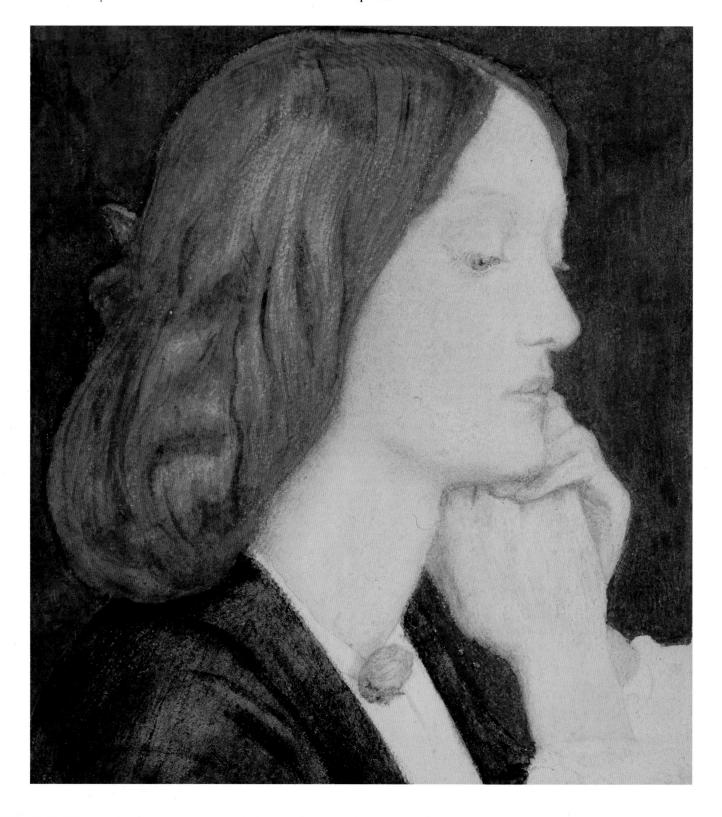

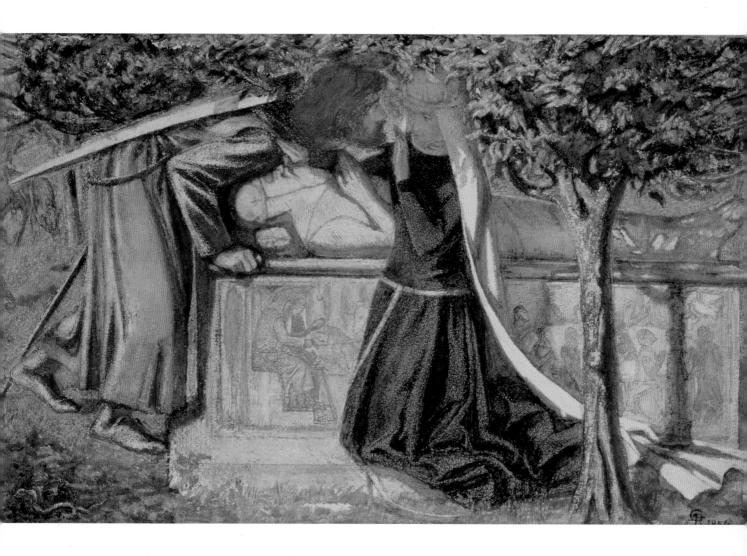

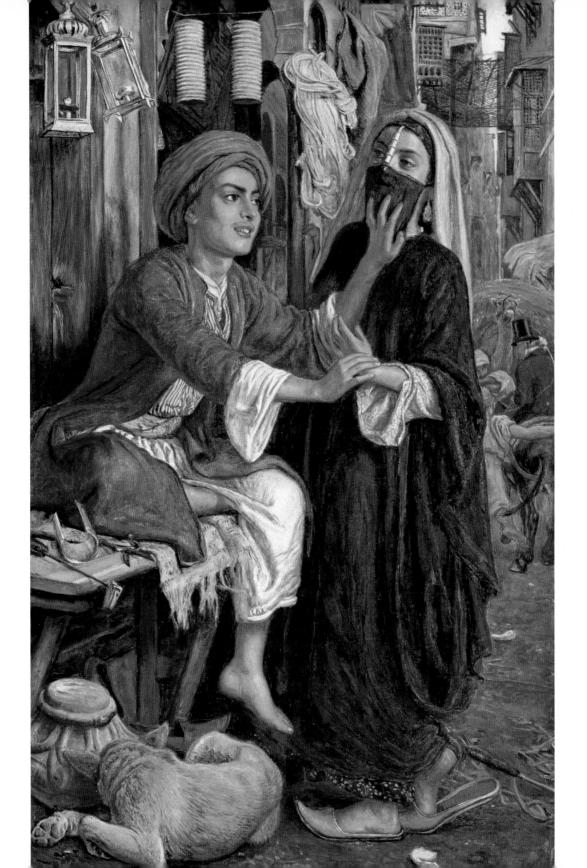

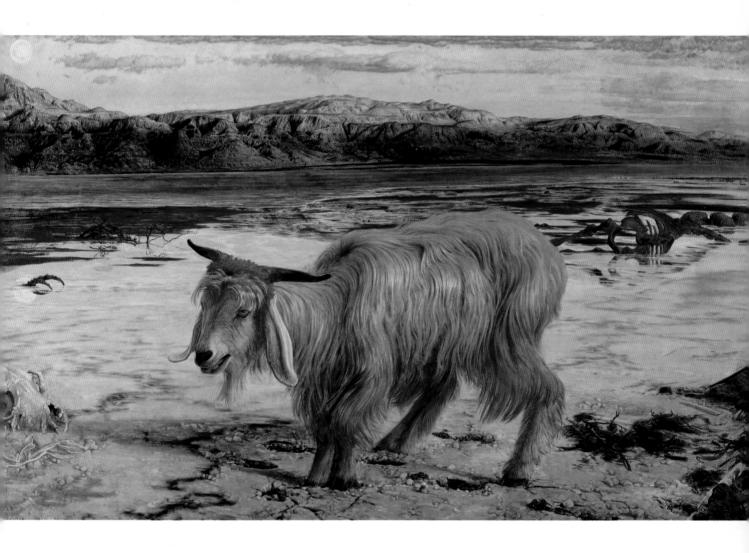

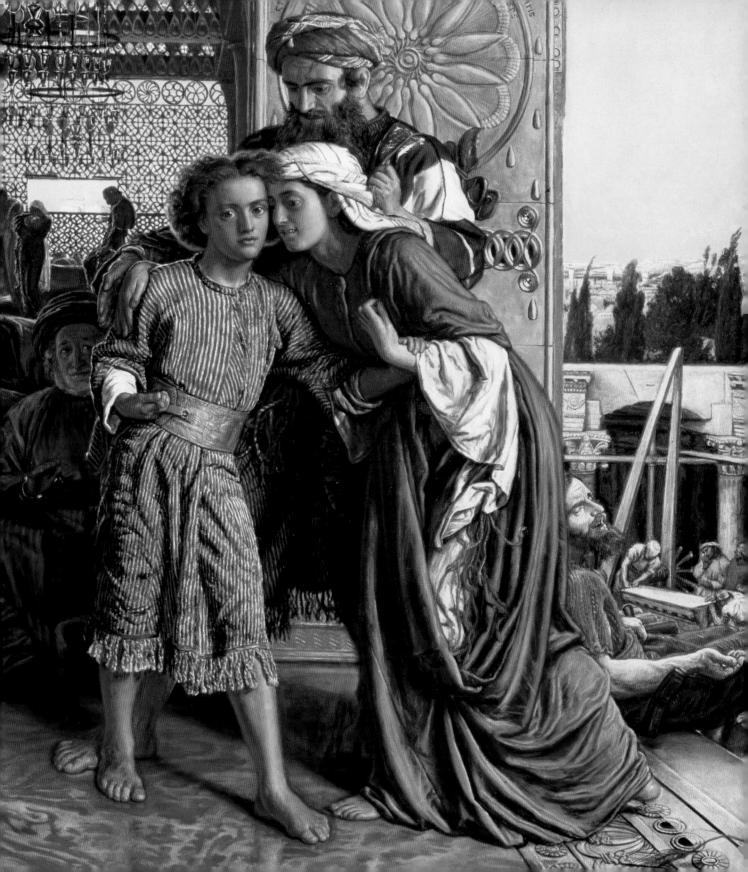

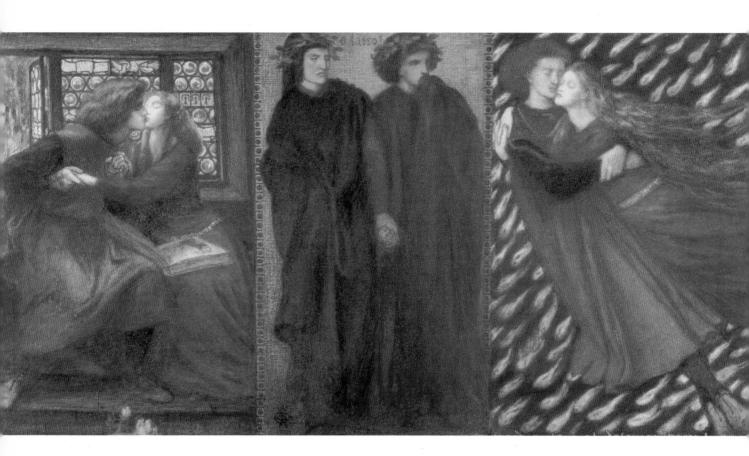

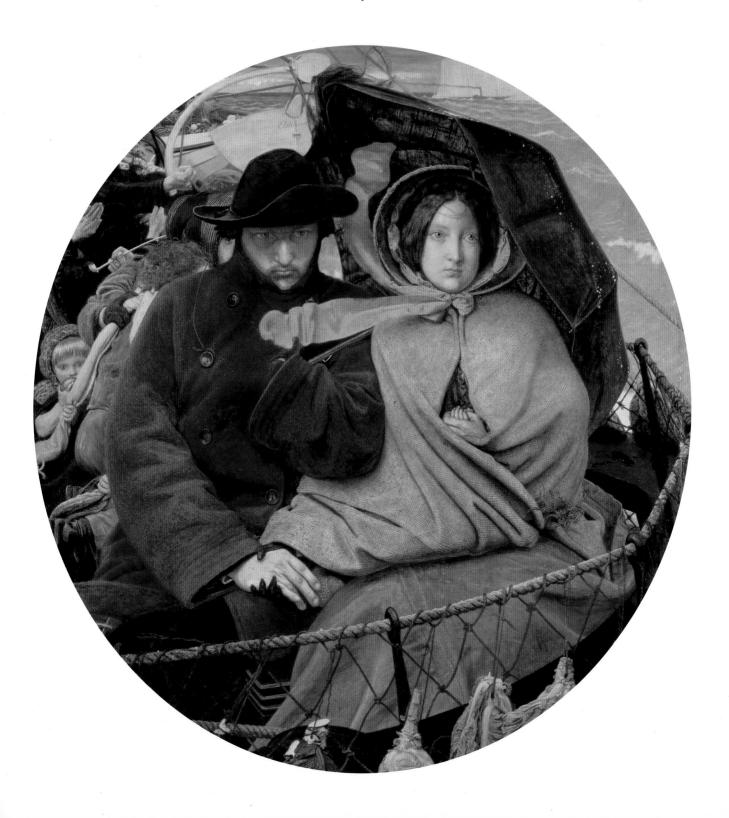

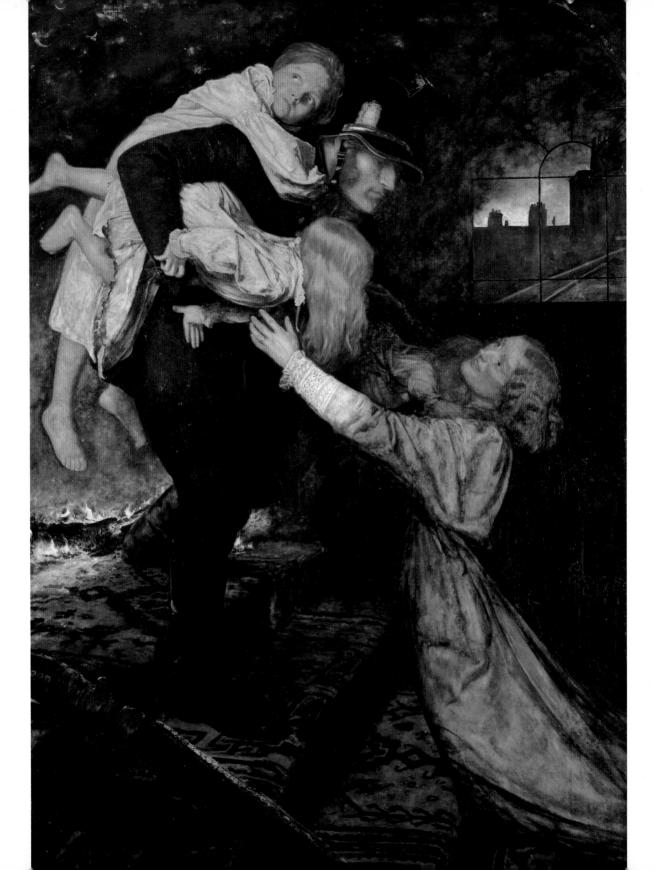

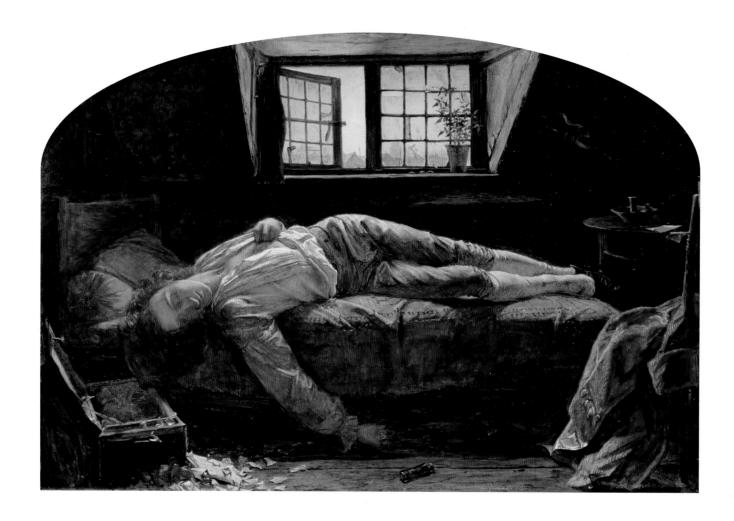

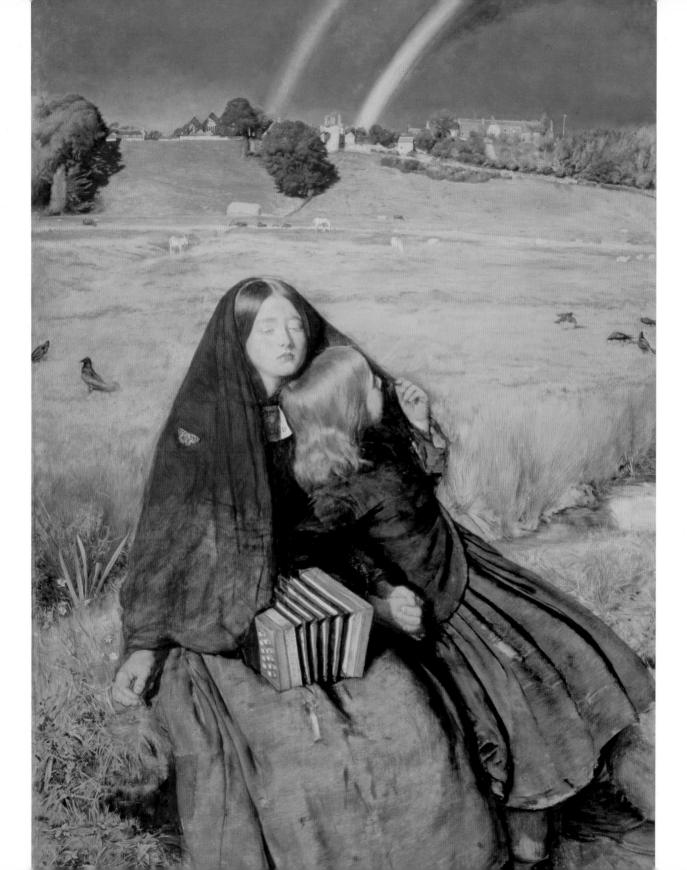

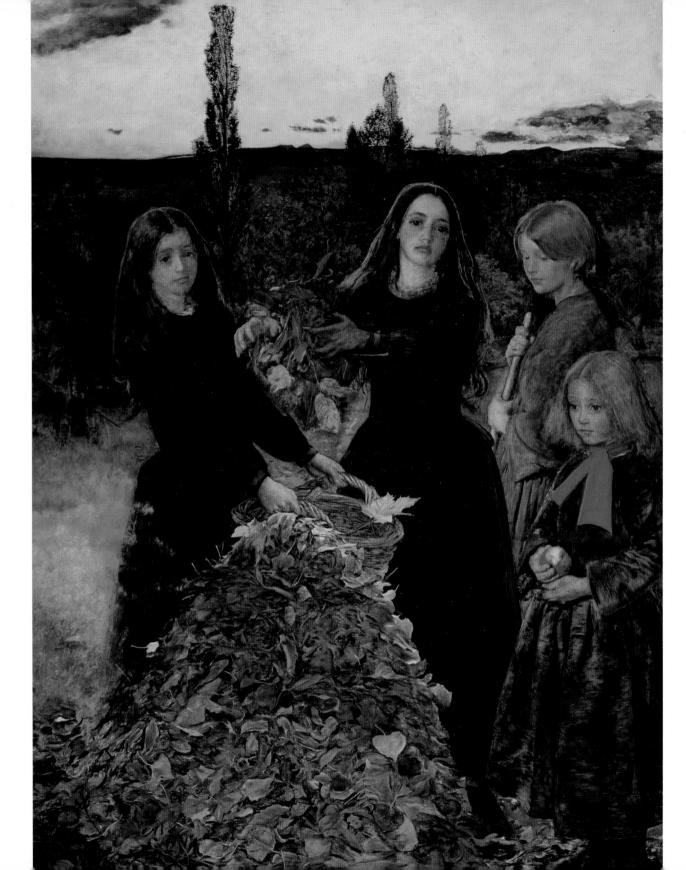

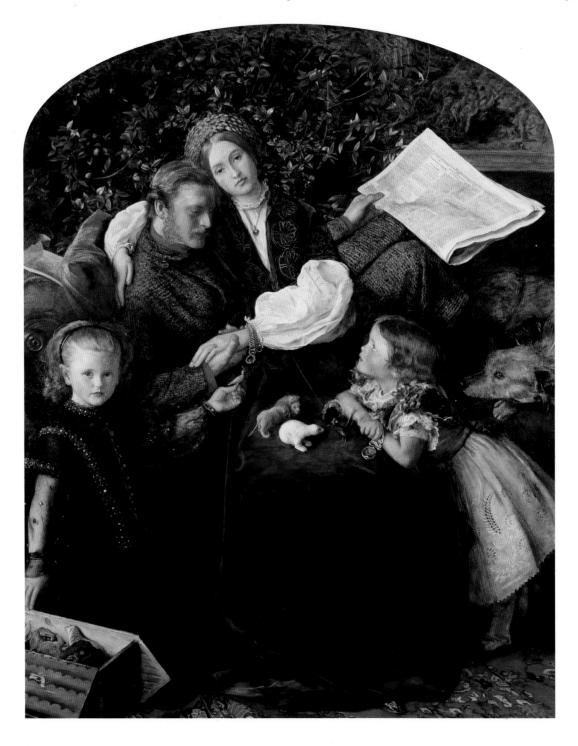

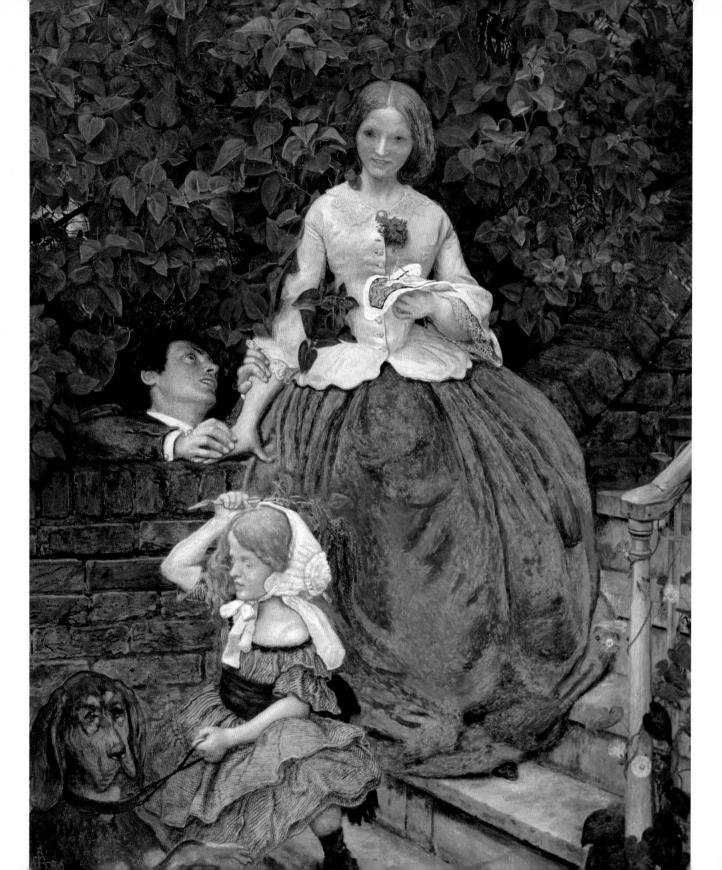

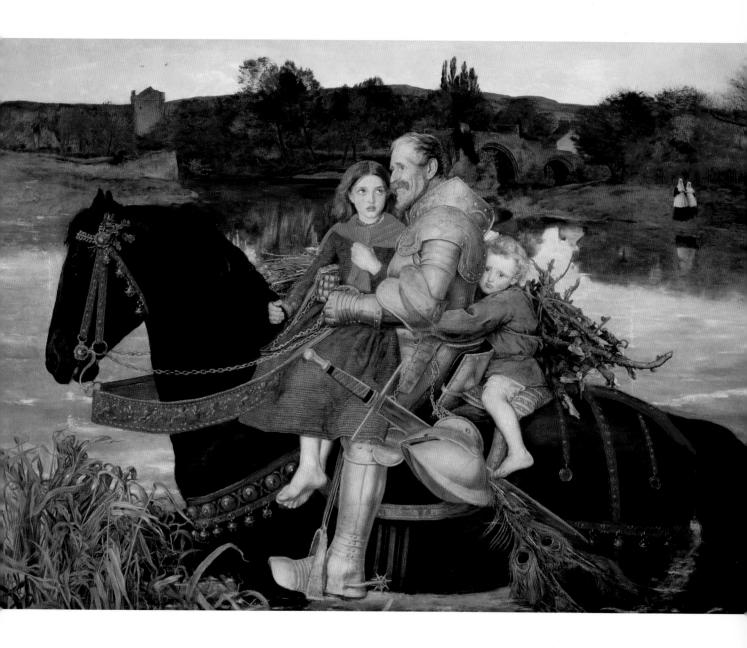

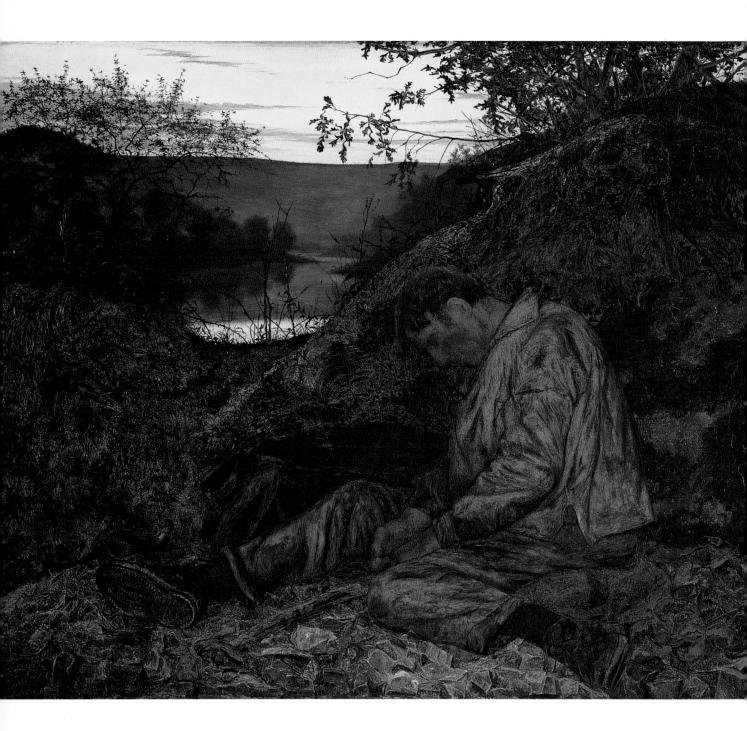

Henry Wallis (1830–1916)

The Stonebreaker, 1857

© Birmingham Museums and Art Gallery/The Bridgeman Art Library Medium: Oil on panel

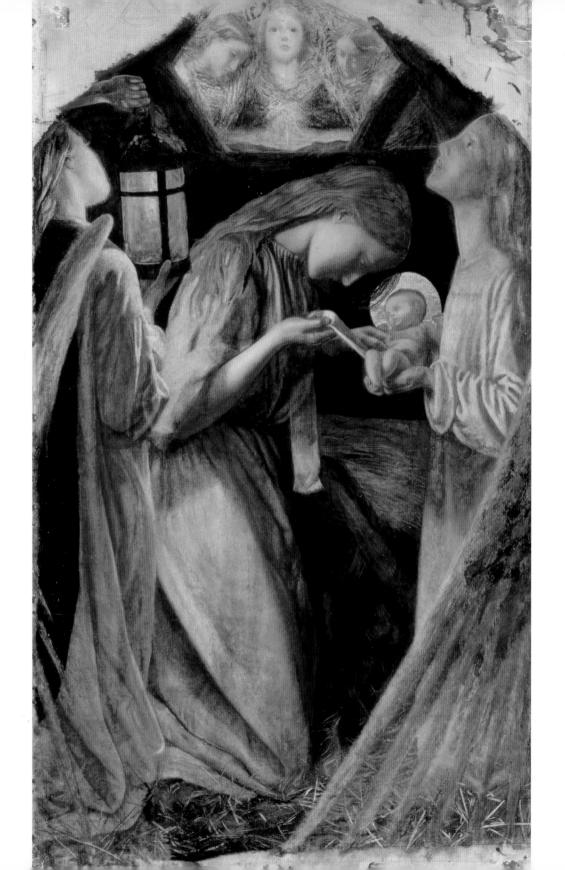

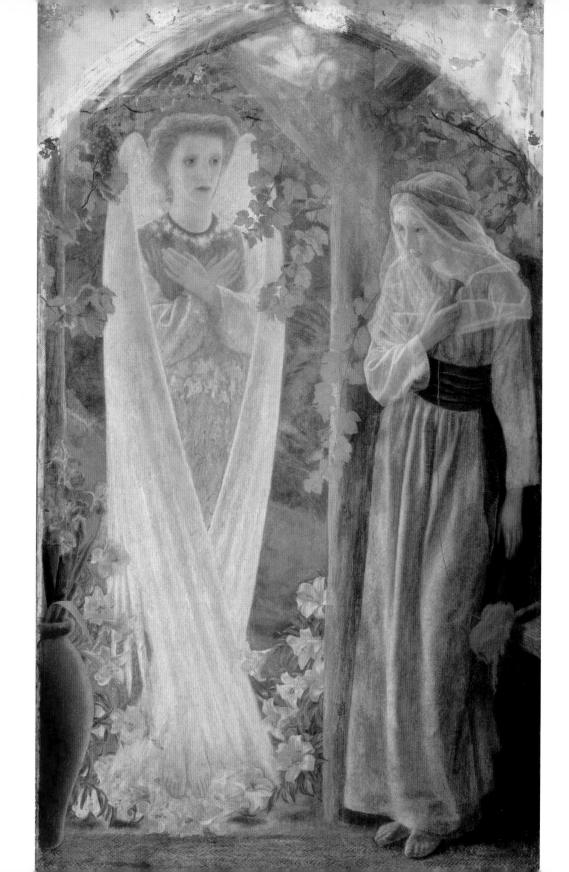

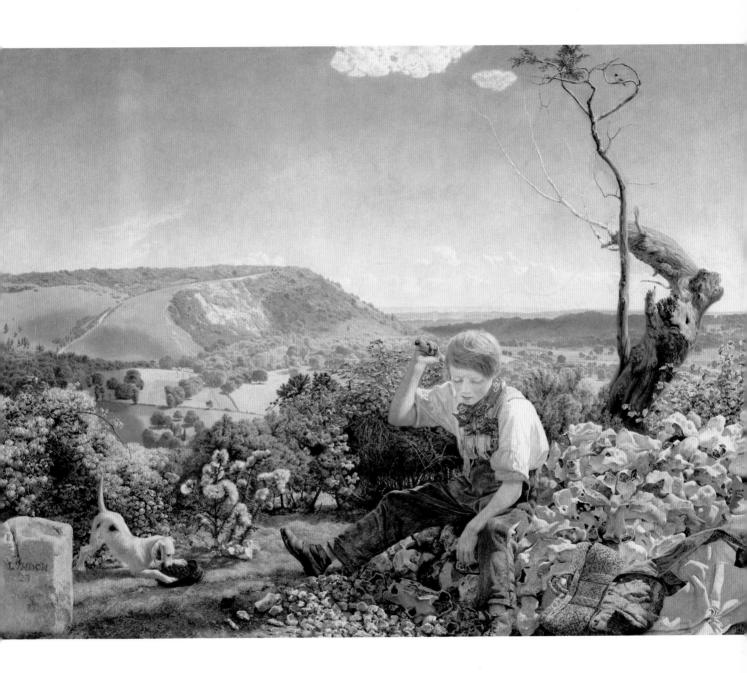

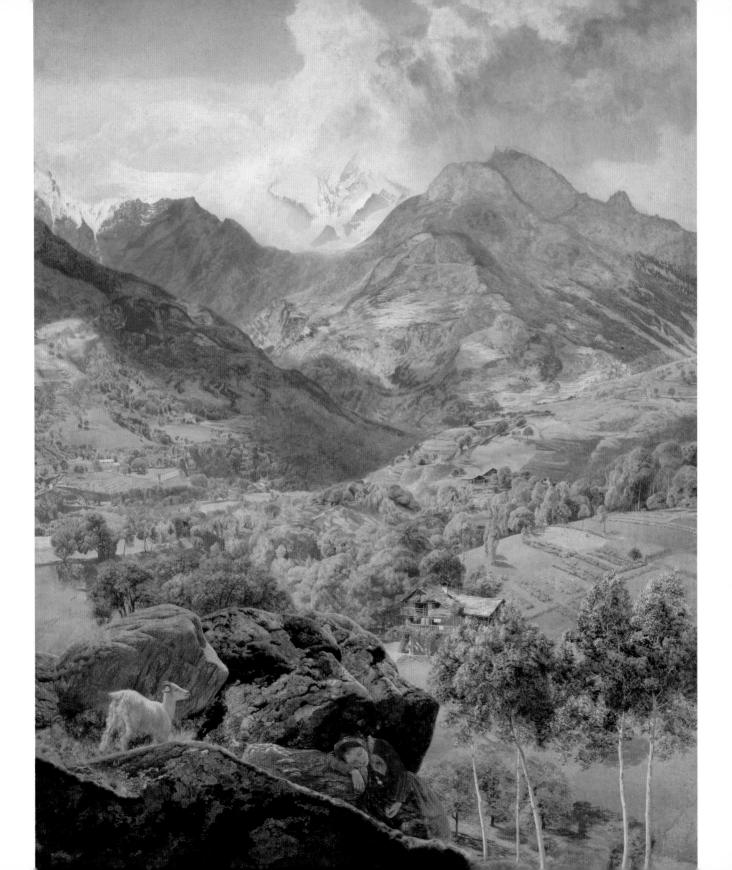

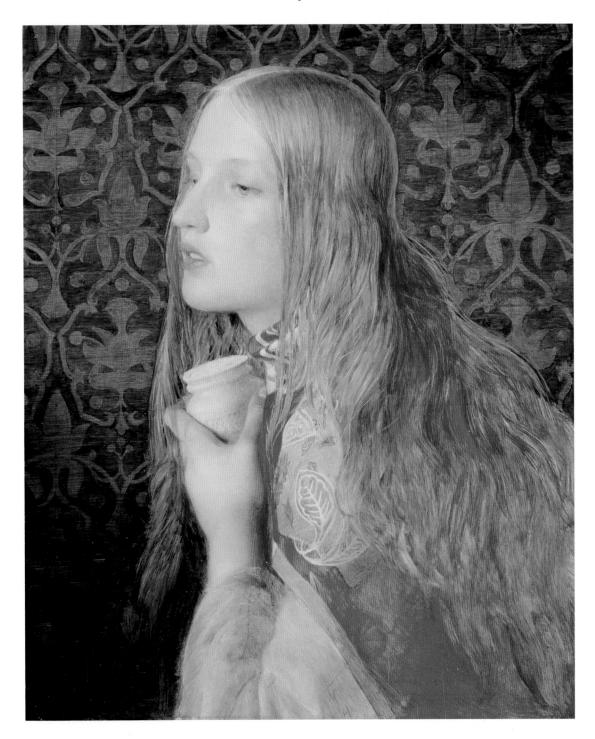

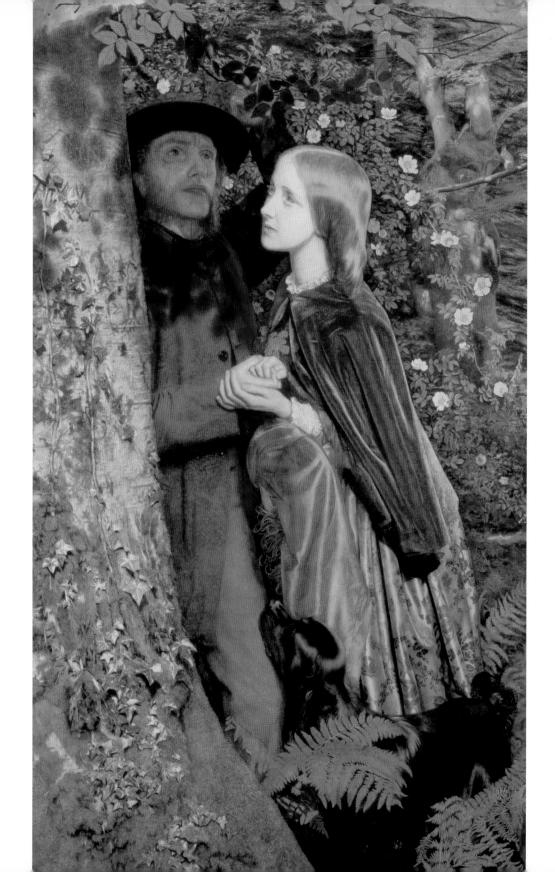

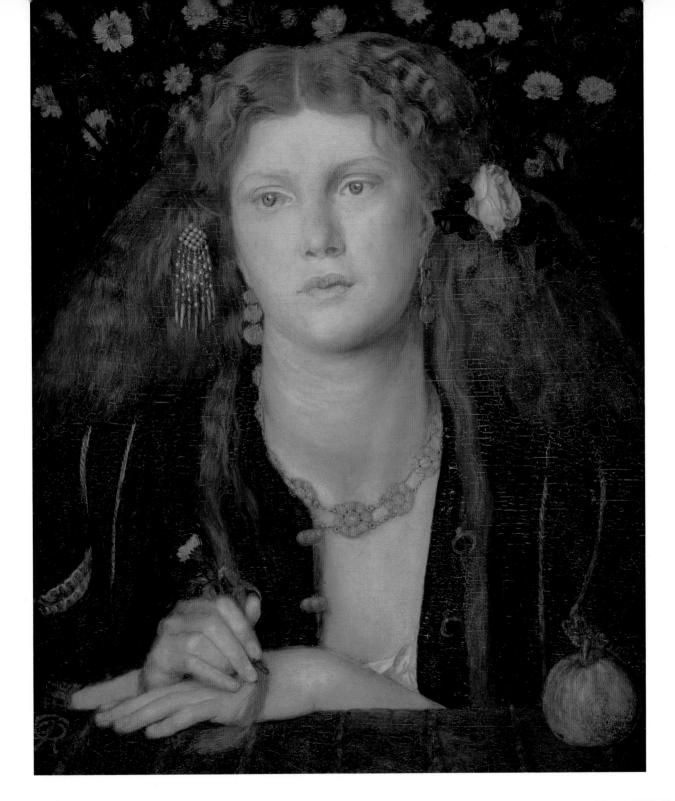

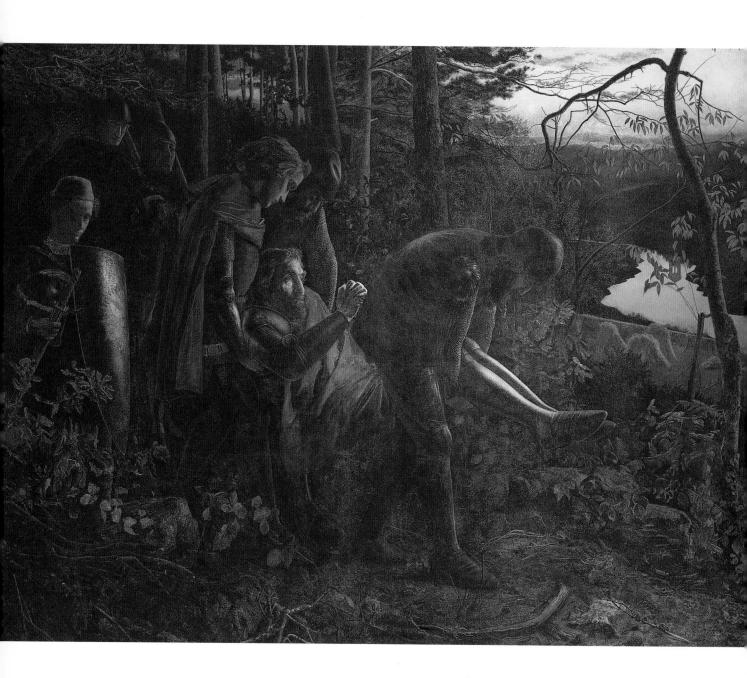

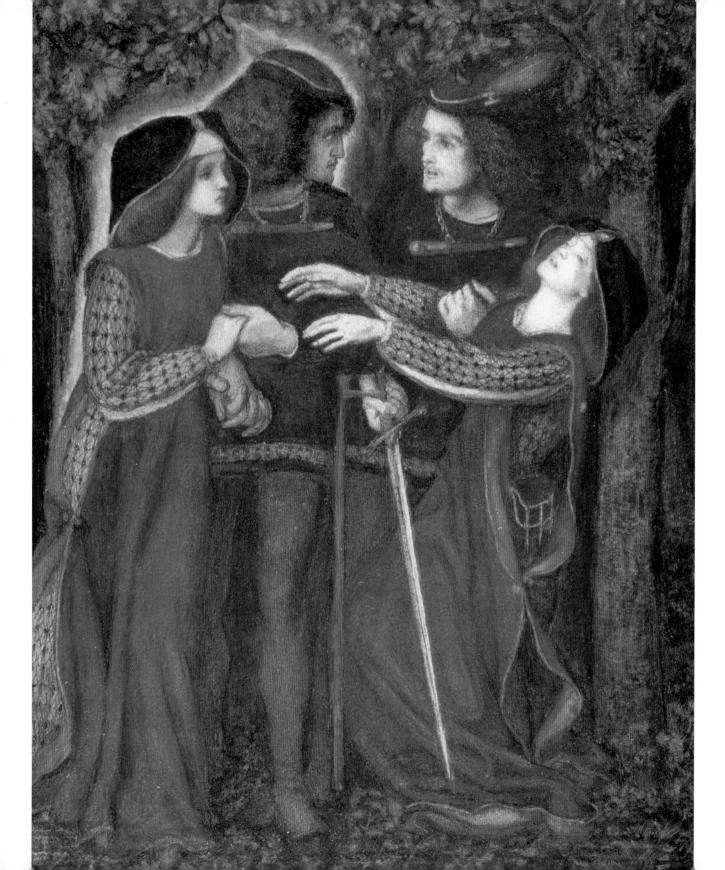

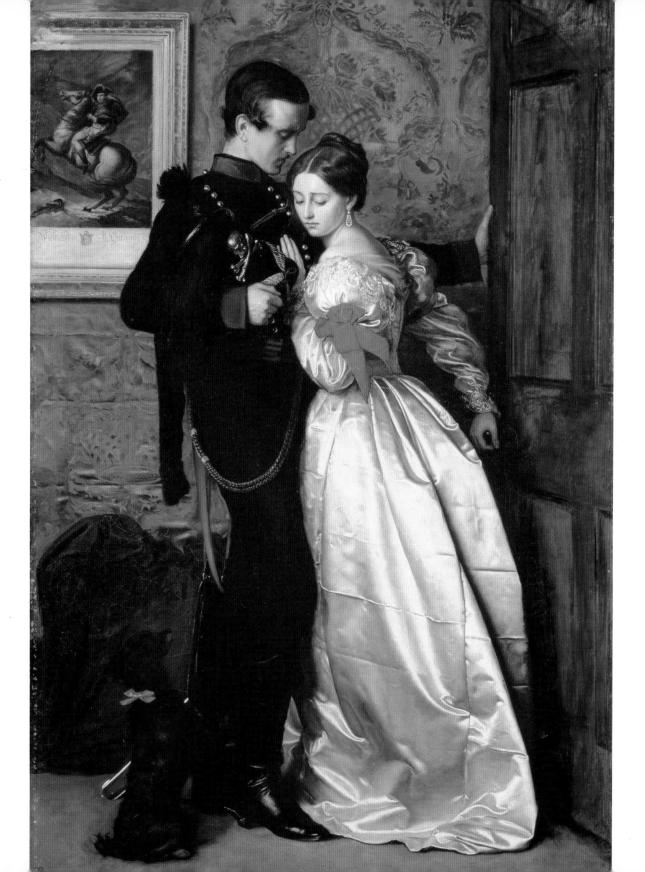

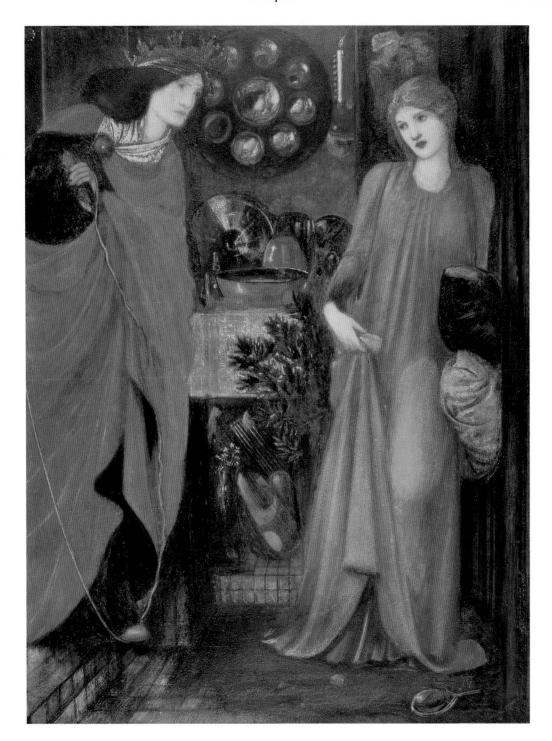

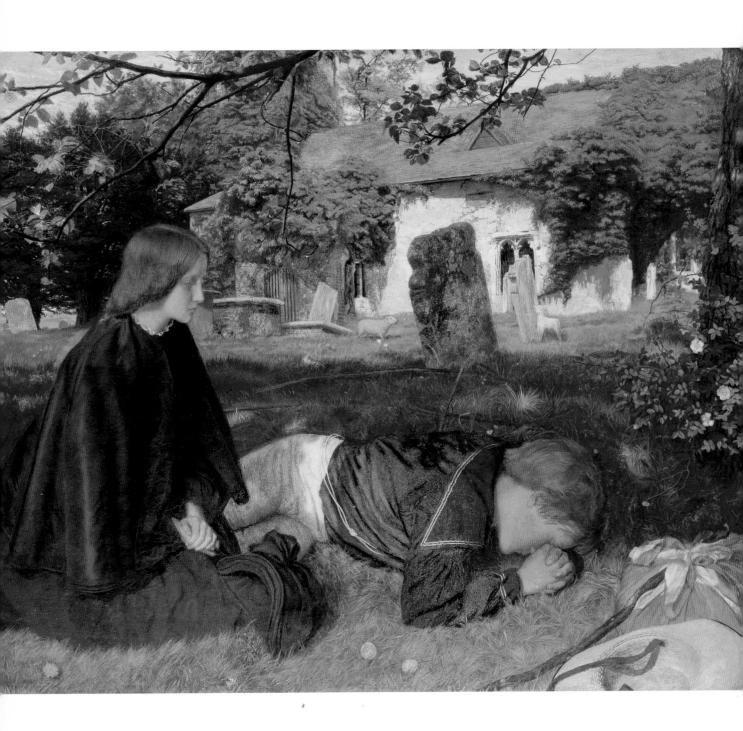

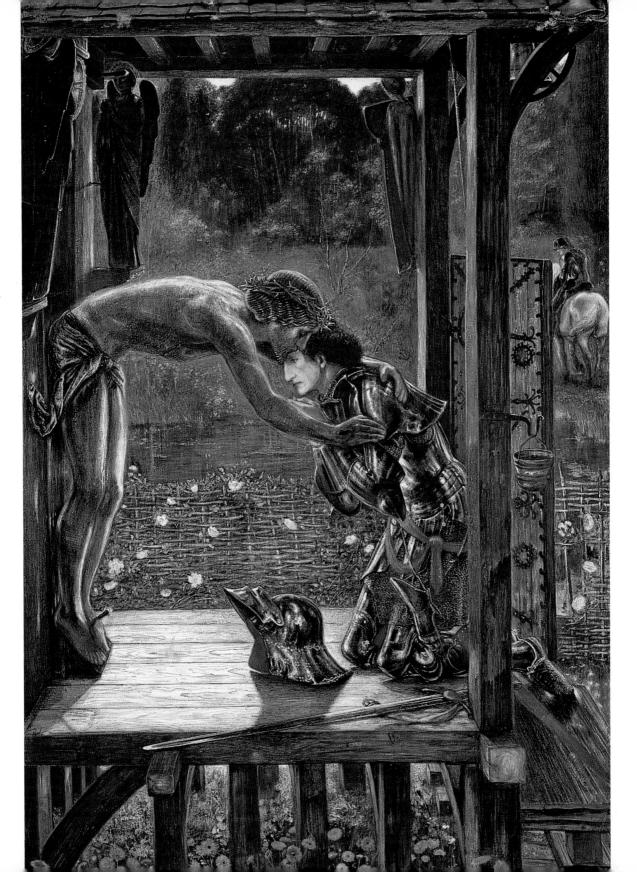

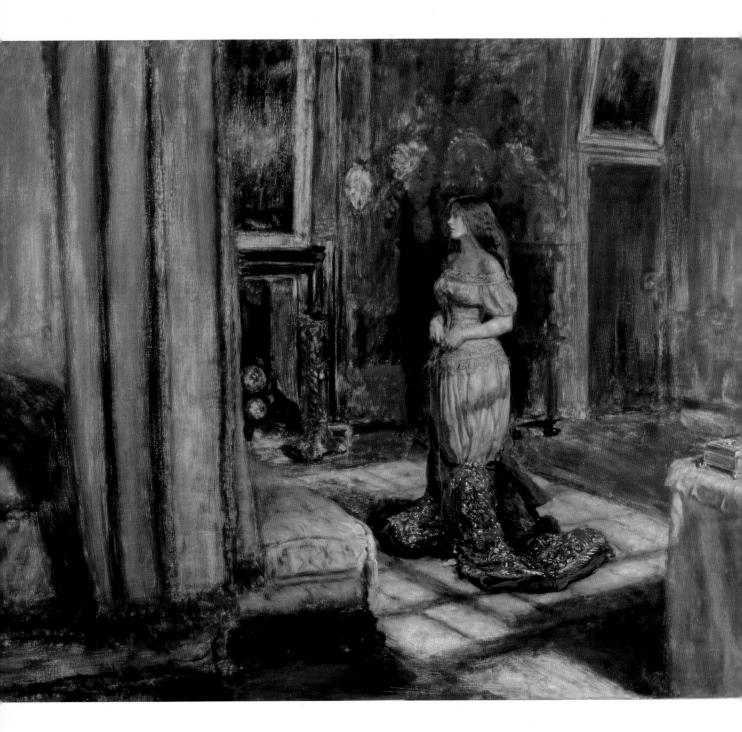

Sir John Everett Millais (1829–96)

The Eve of St Agnes, 1863

The Royal Collection © 2011 Her Majesty Queen Elizabeth II/The Bridgeman Art Library Medium: Oil on canvas

Dante Gabriel Rossetti (1828–82)
Beata Beatrix, c. 1863
© Birmingham Museums and Art Gallery/The Bridgeman Art Library
Medium: Oil on canvas

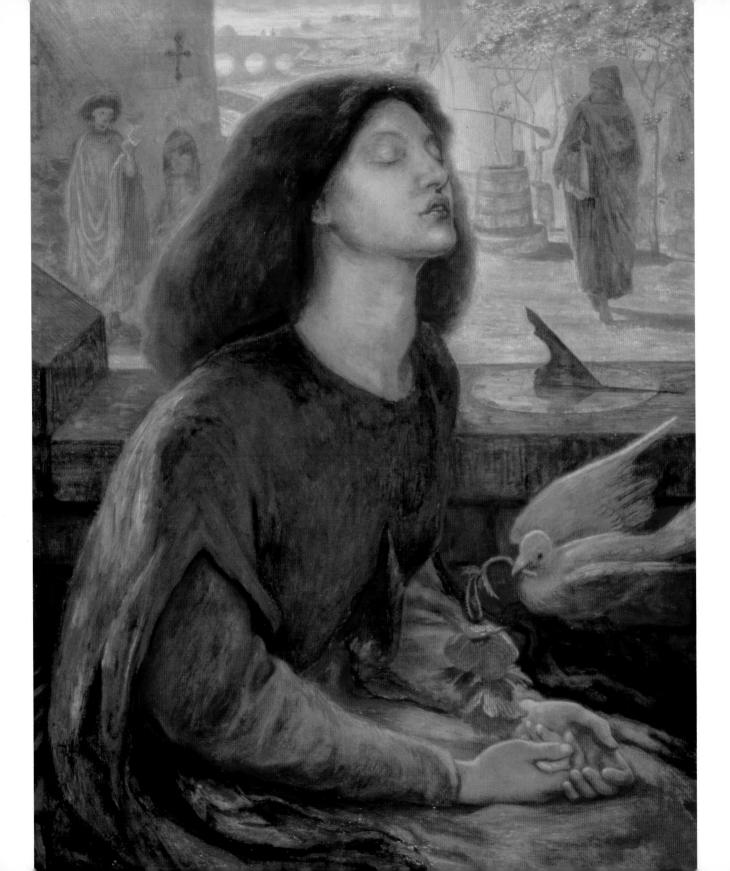

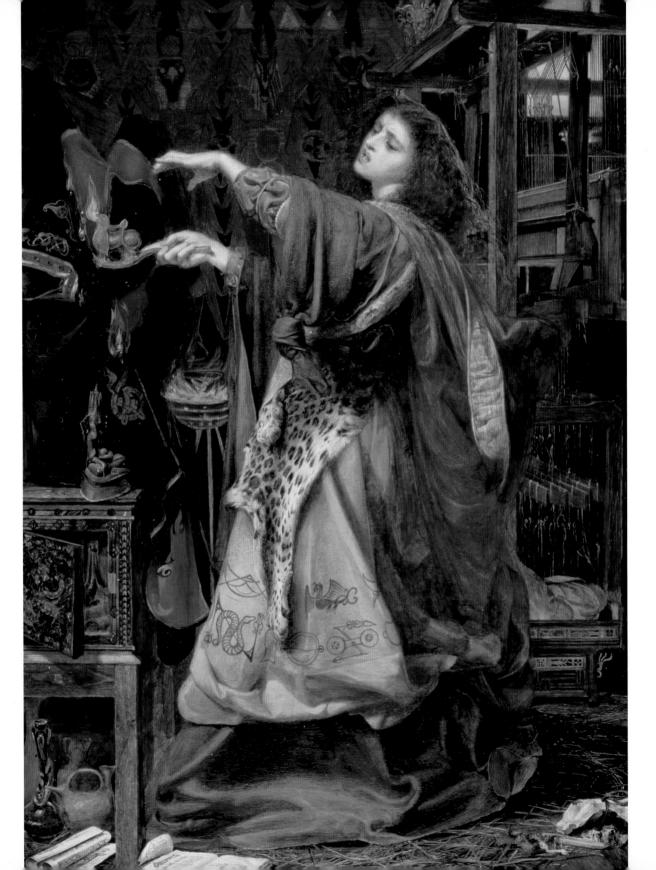

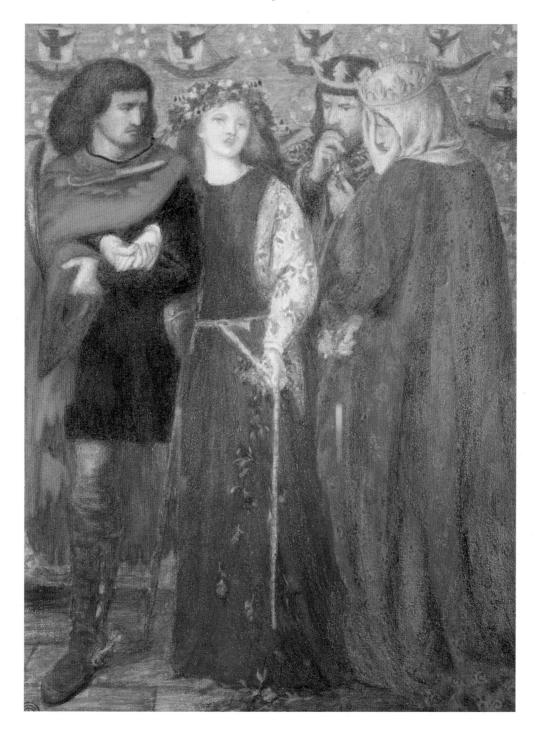

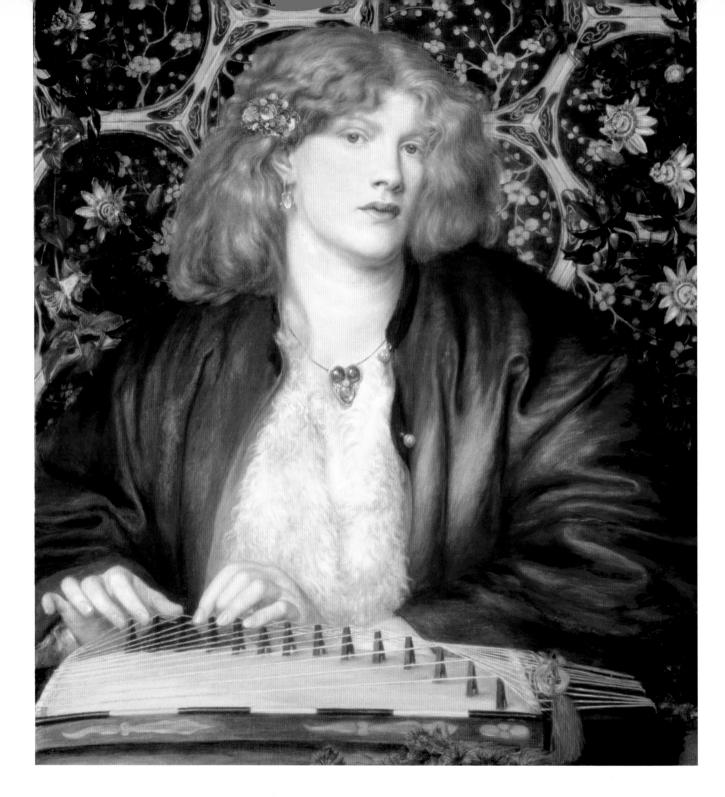

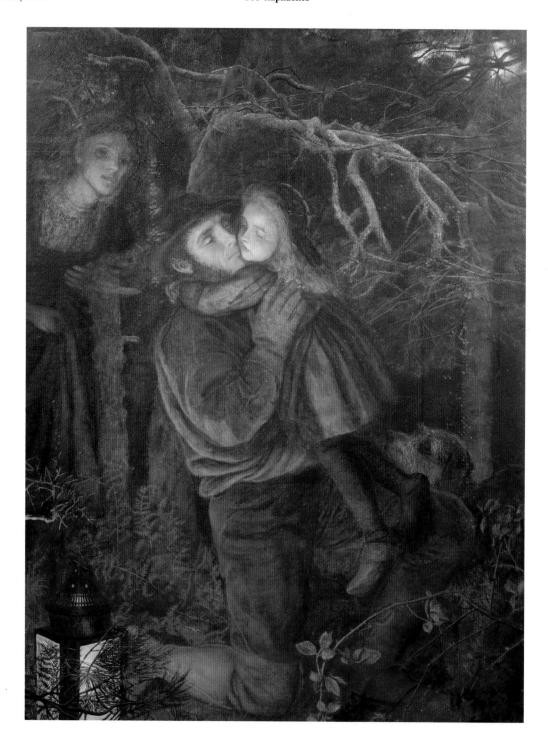

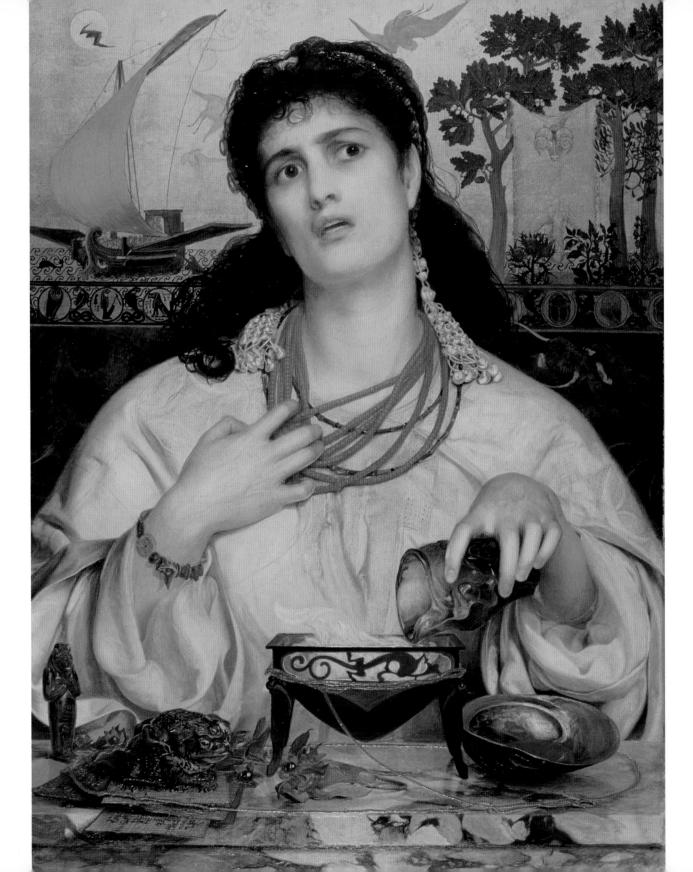

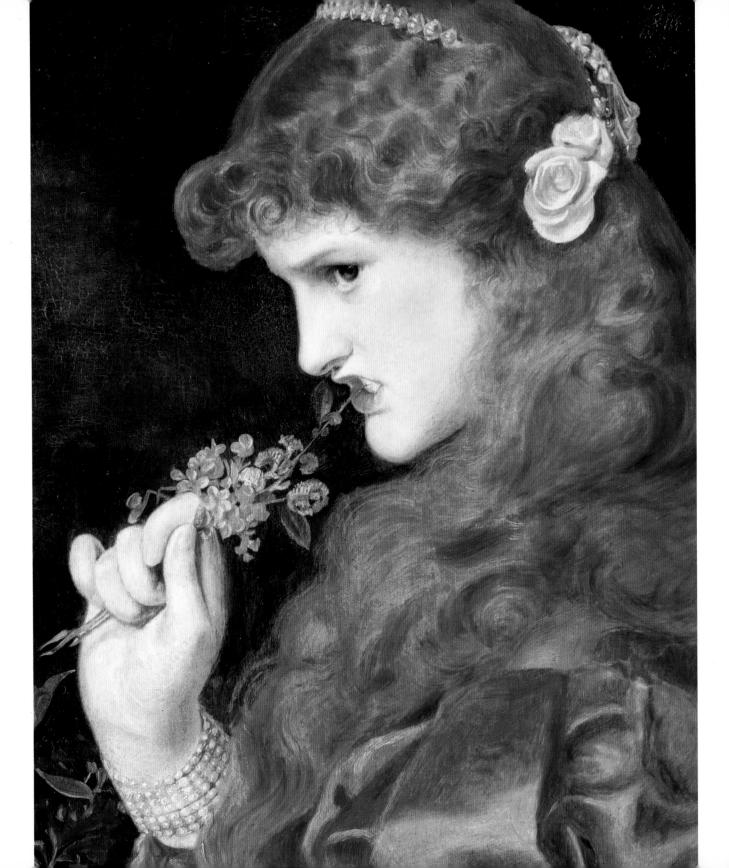

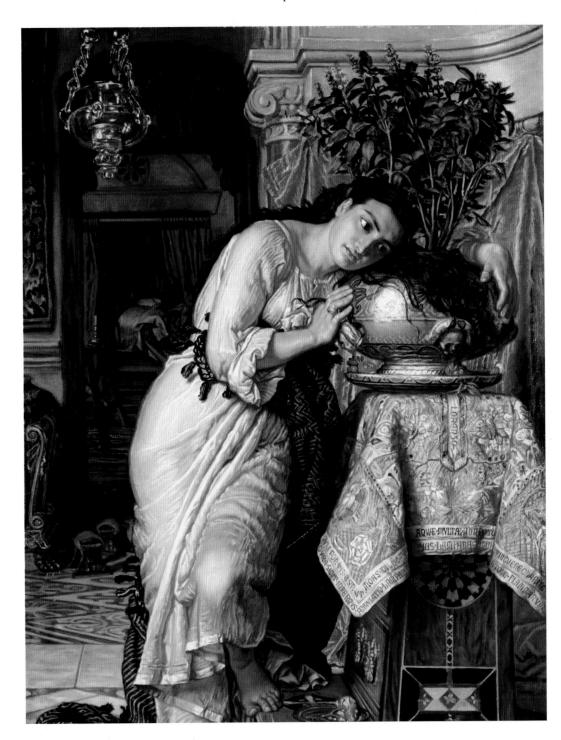

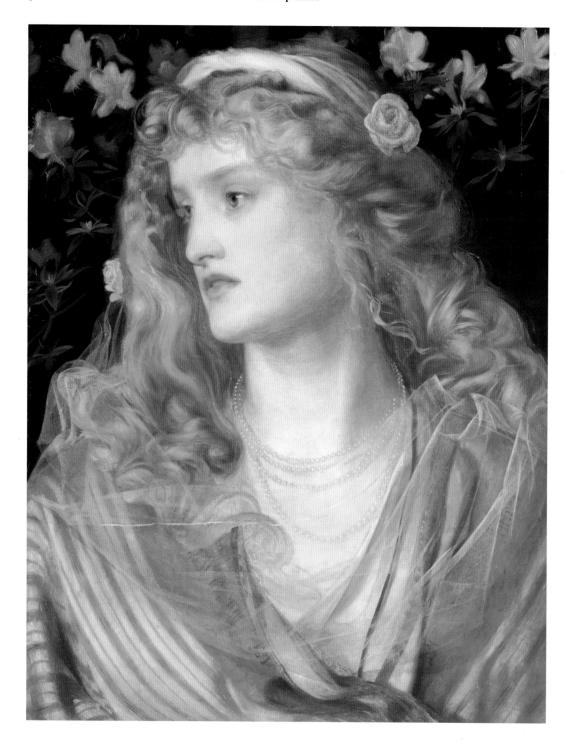

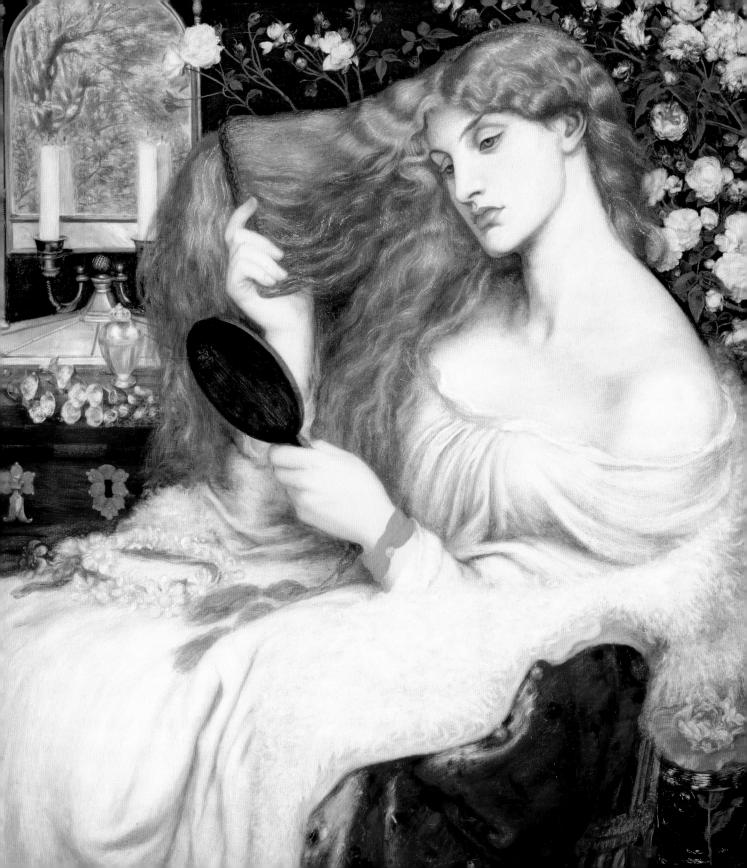

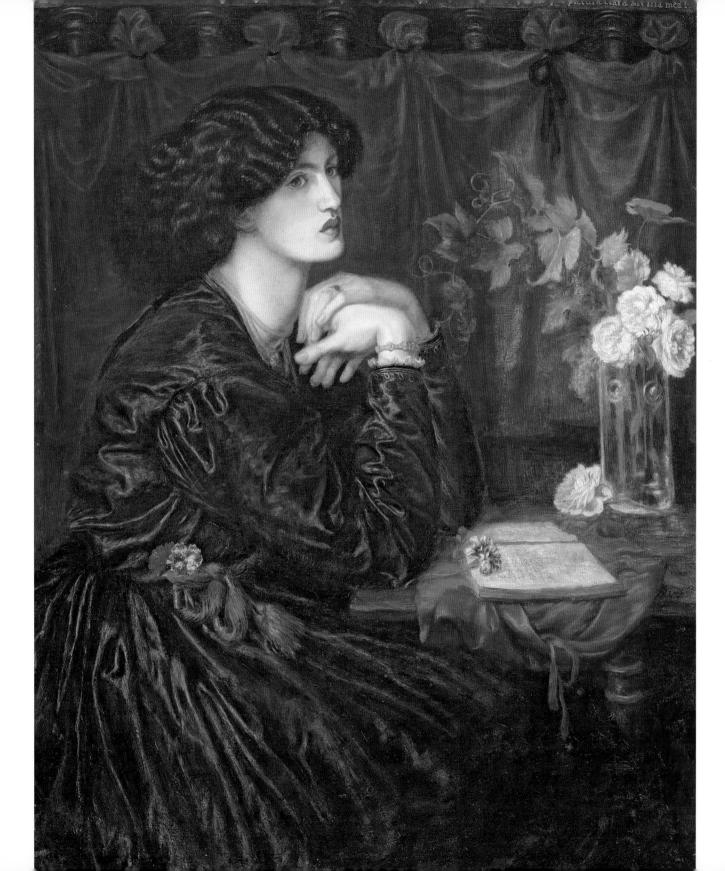

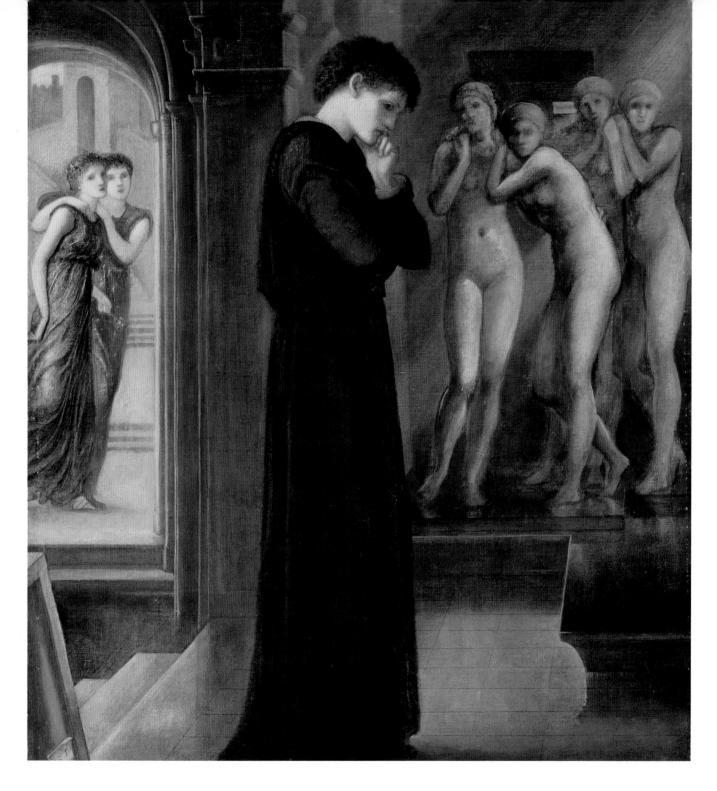

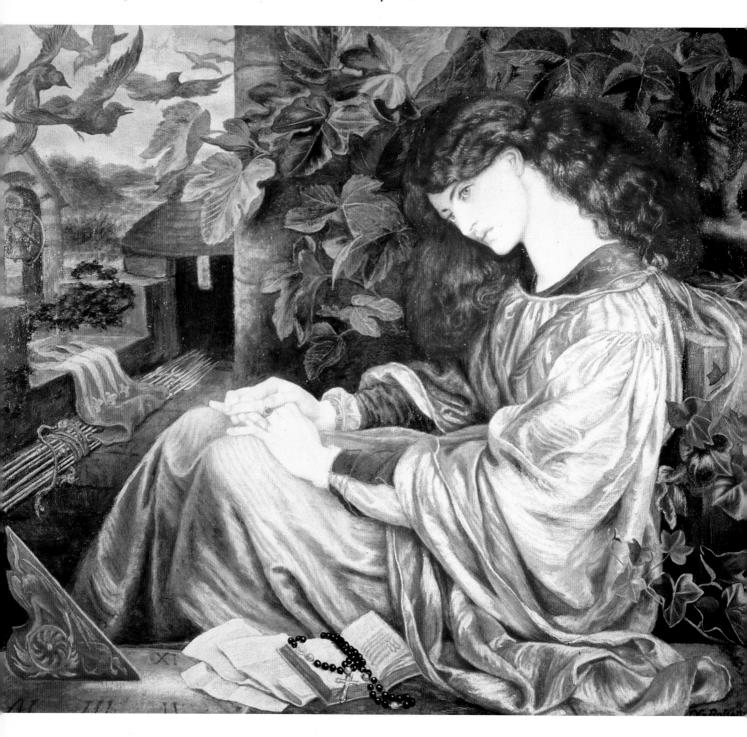

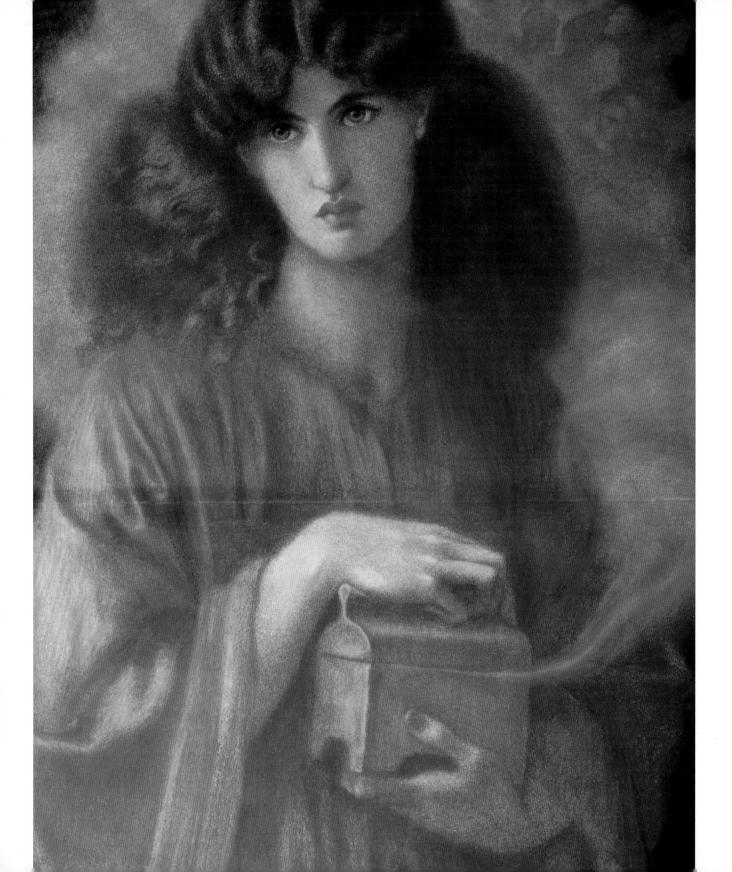

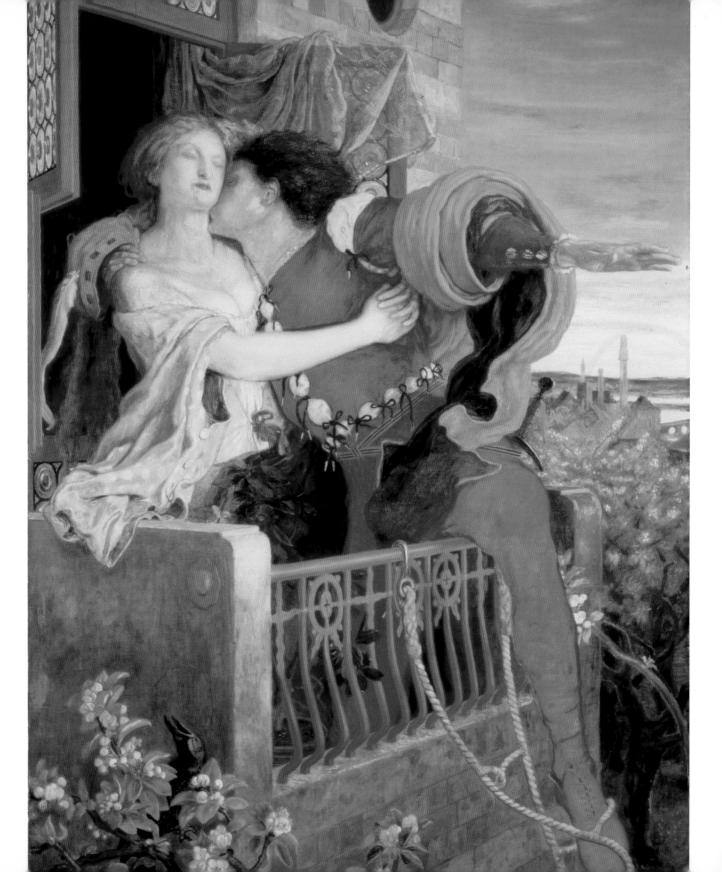

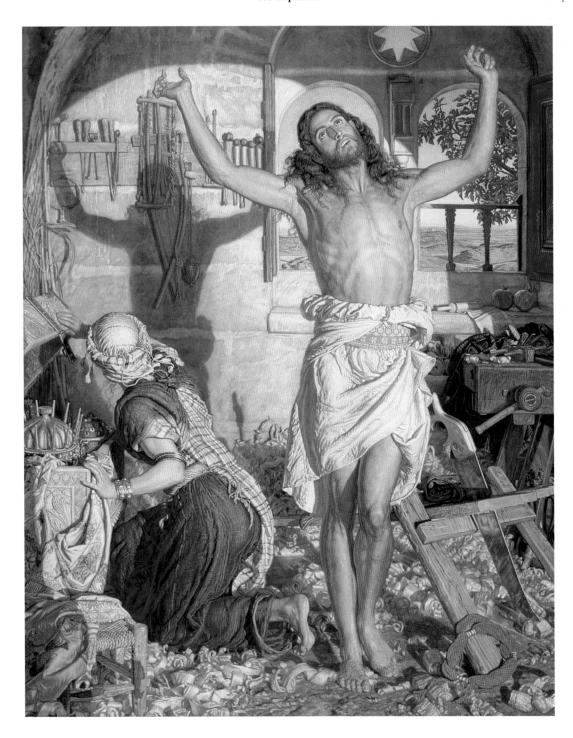

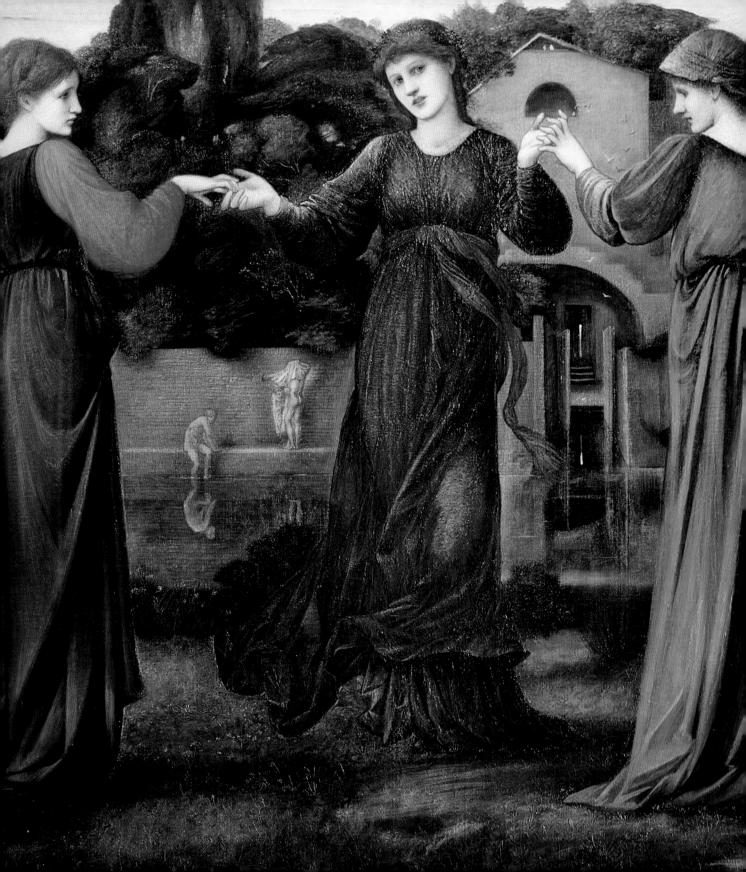

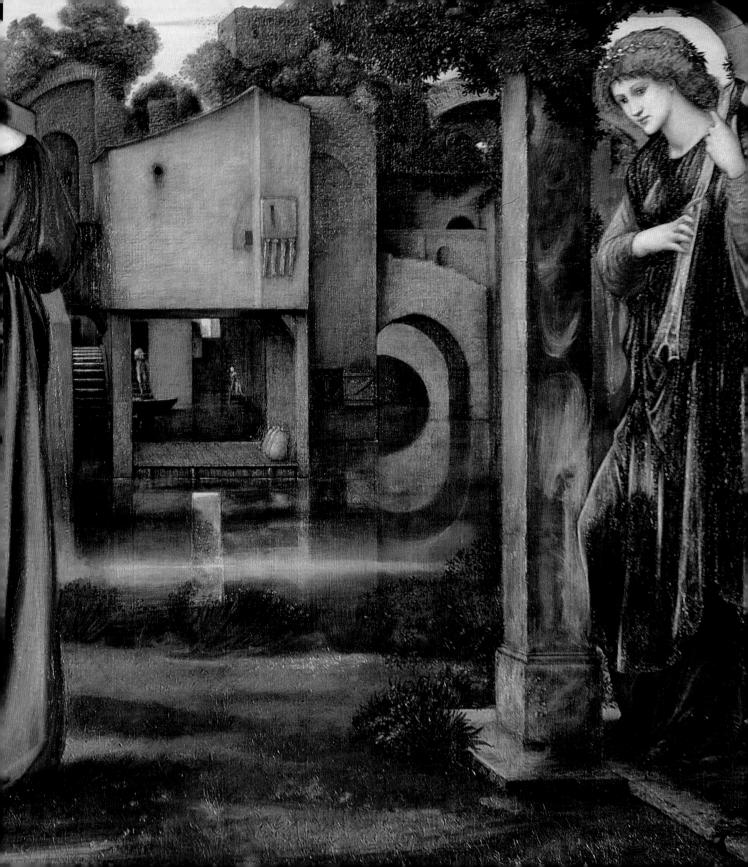

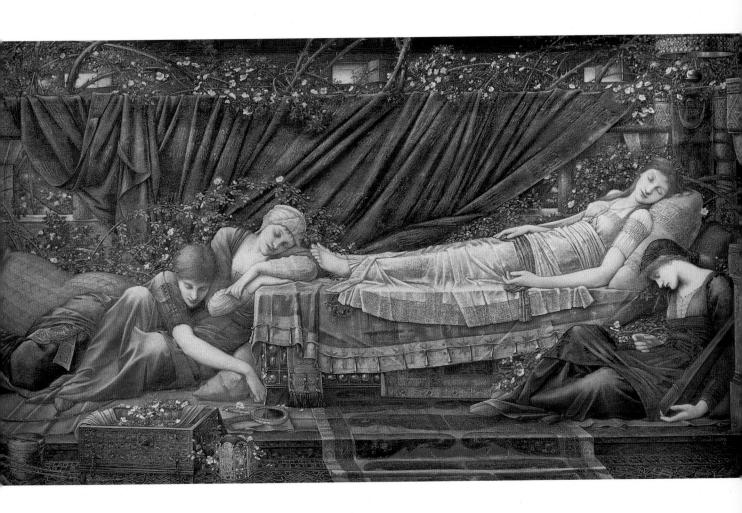

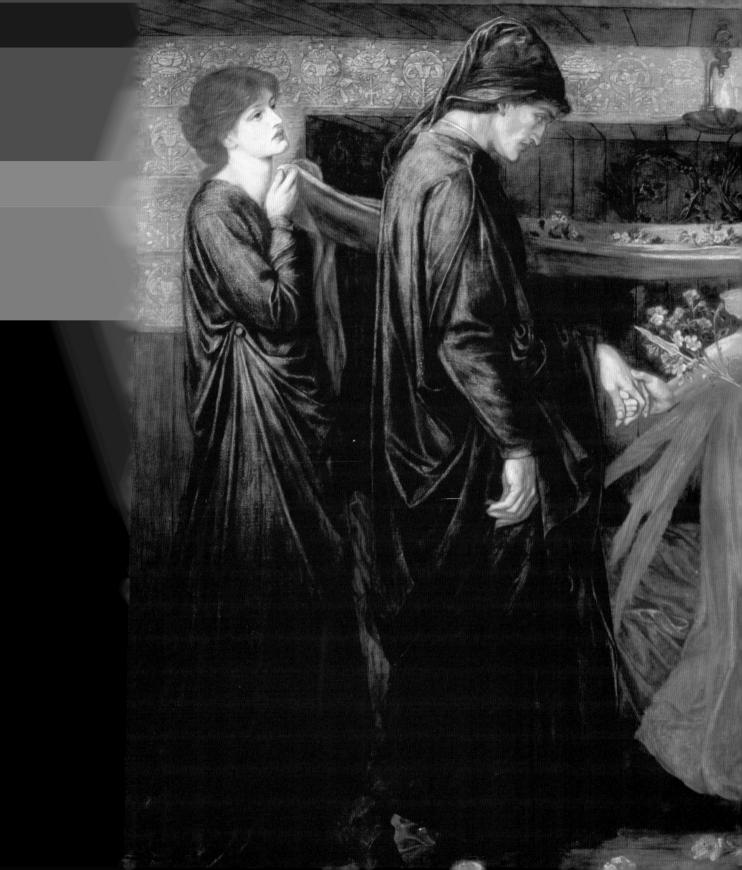

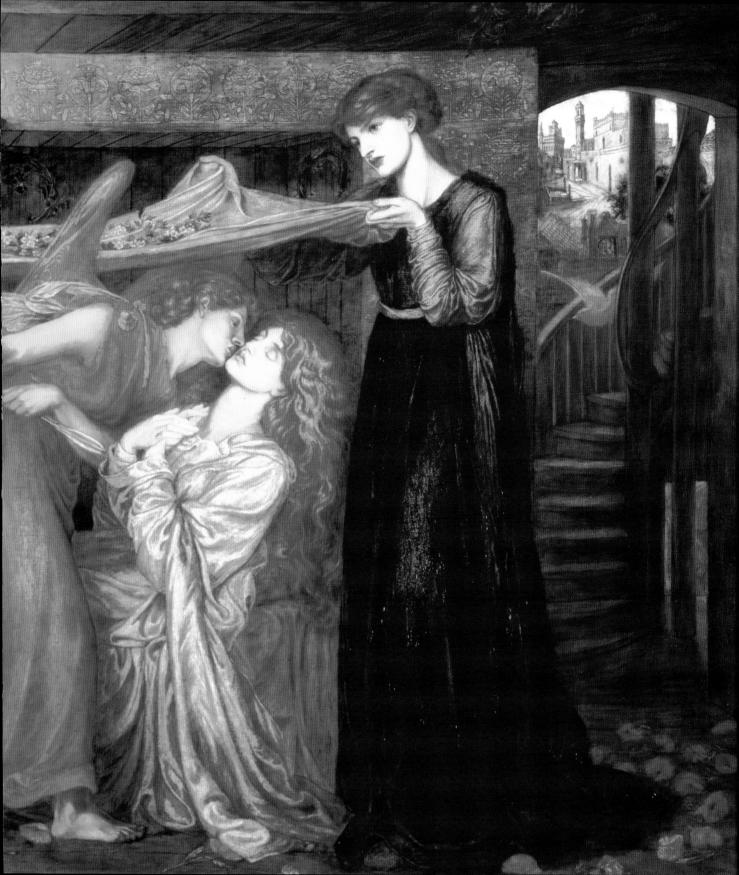

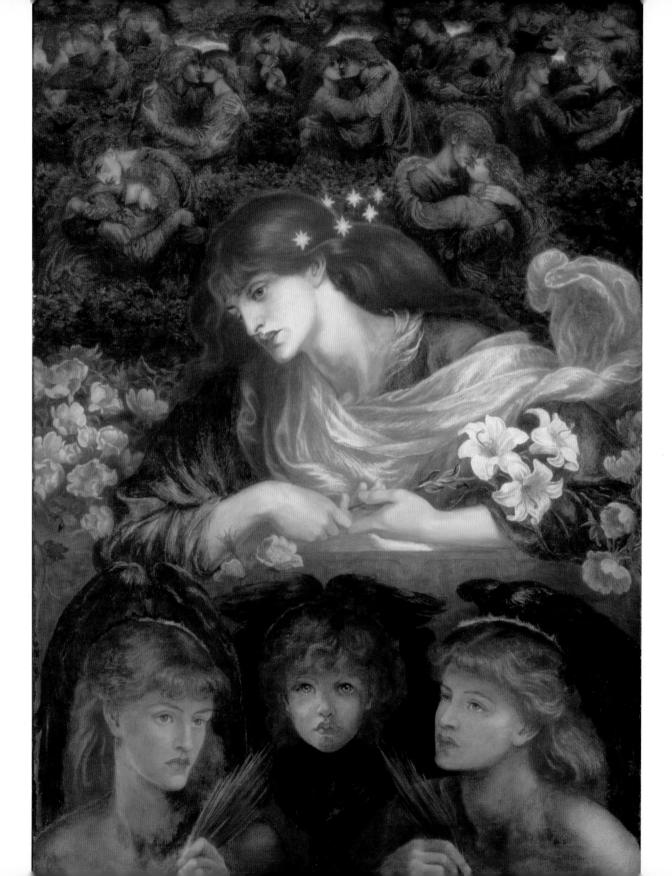

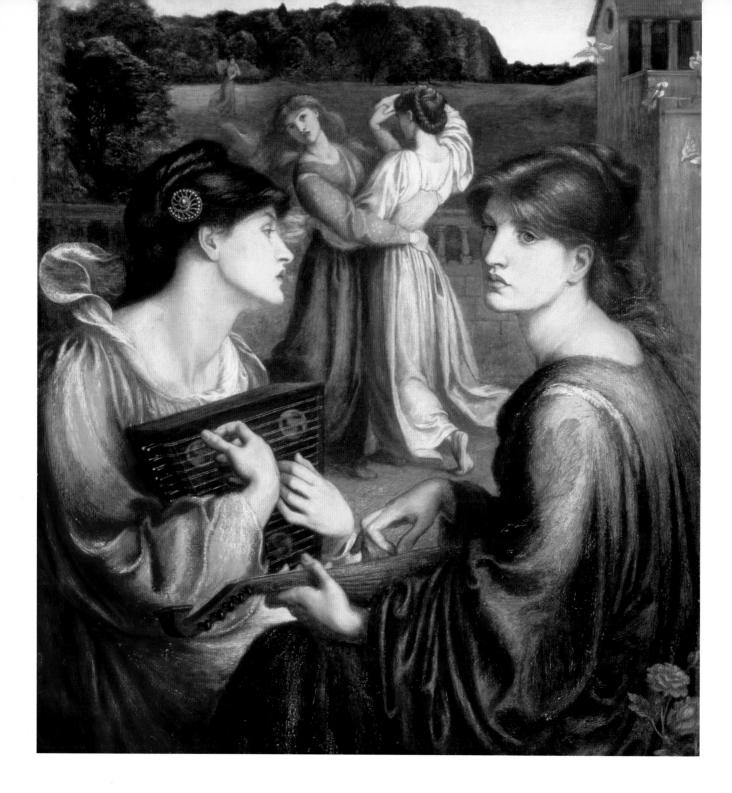

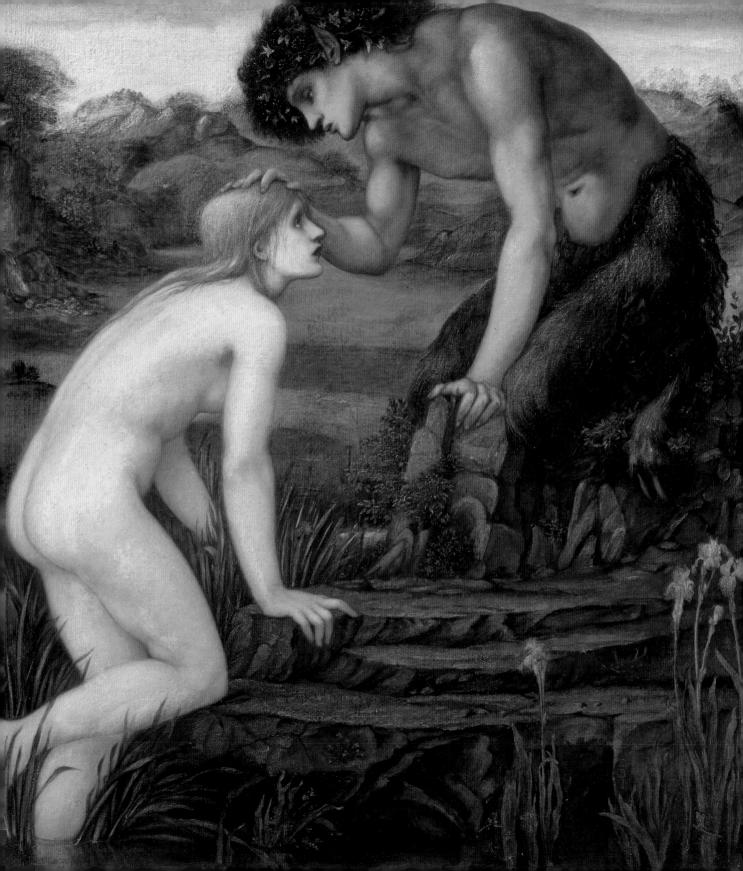

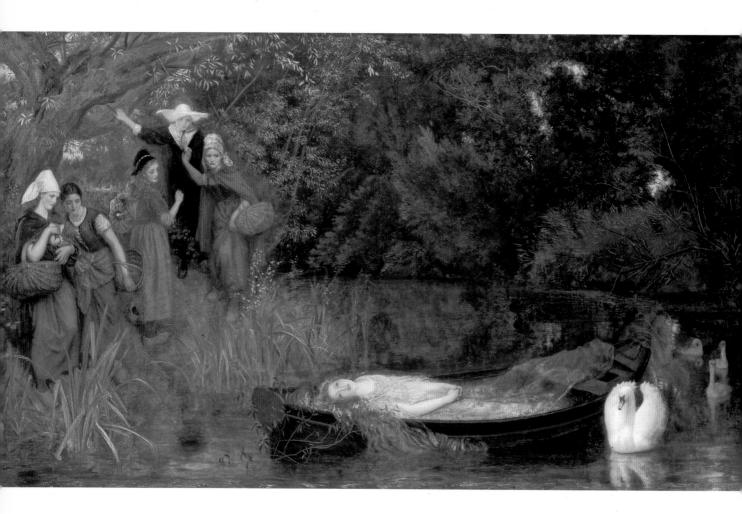

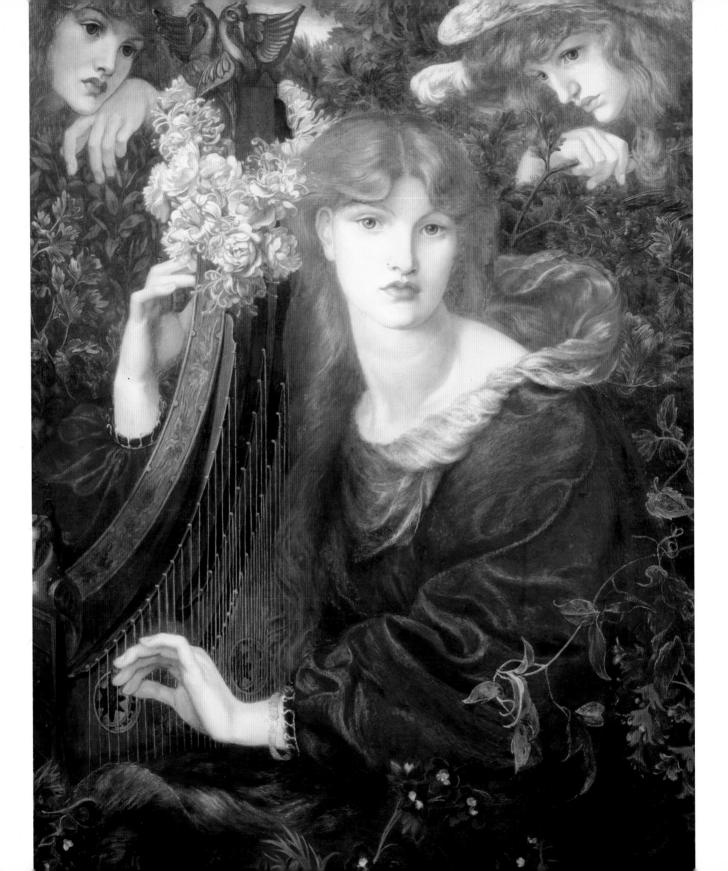

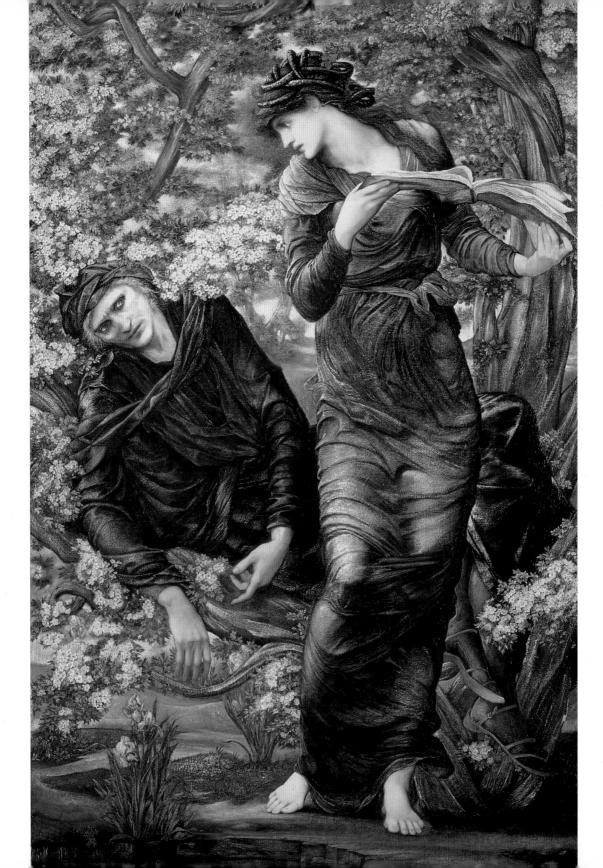

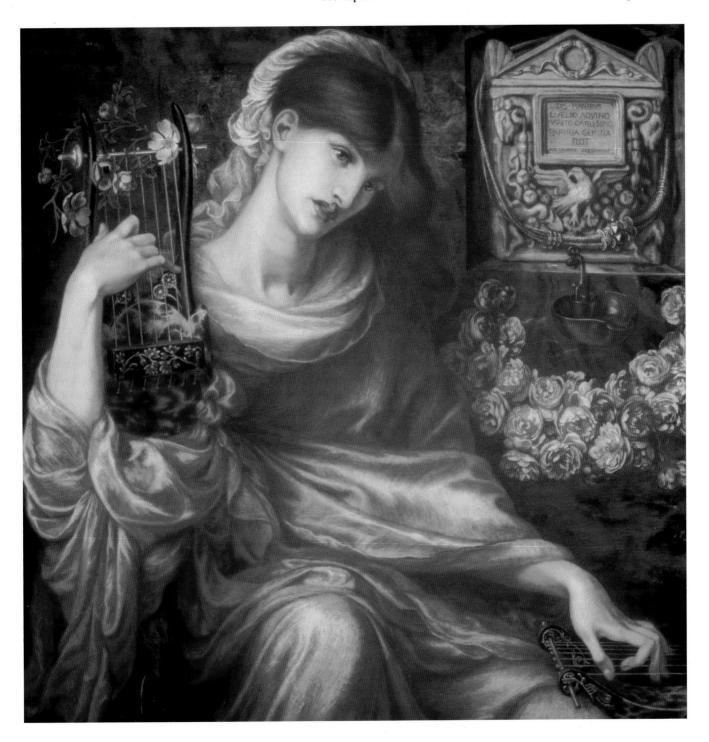

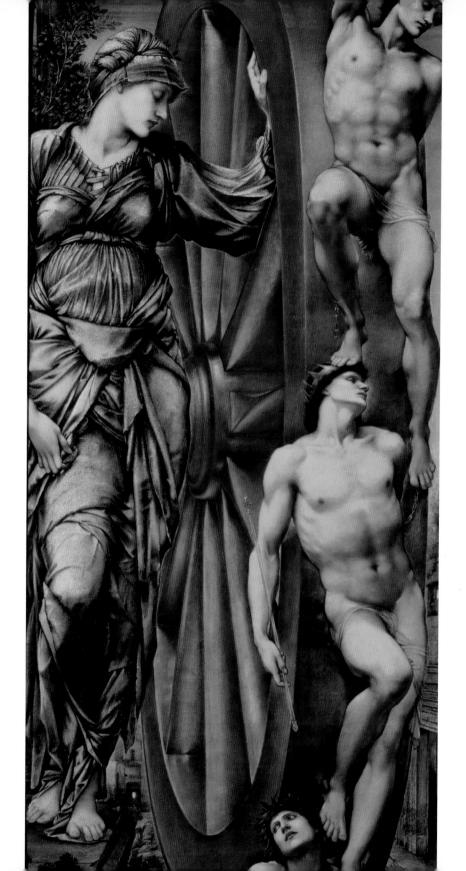

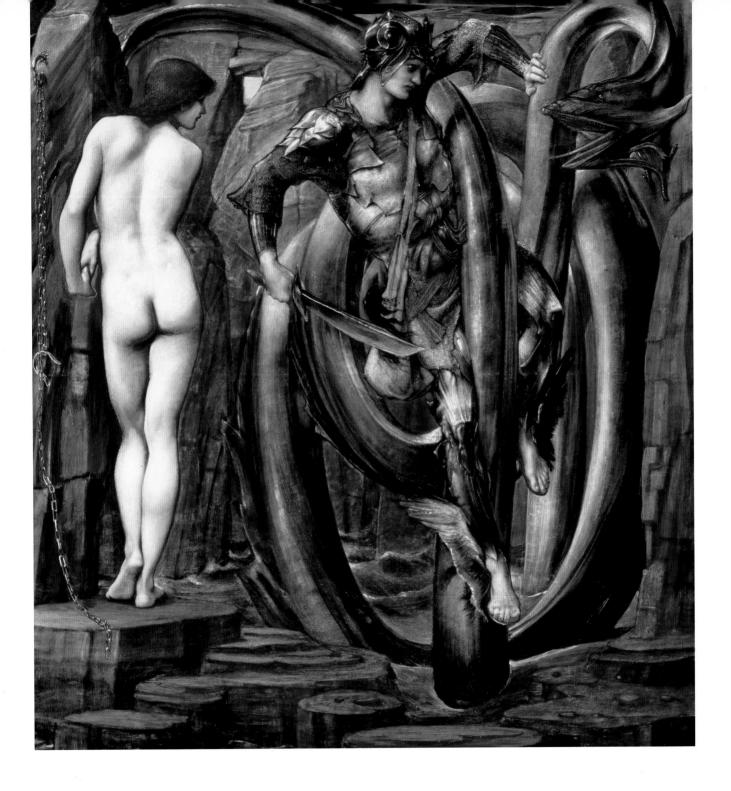

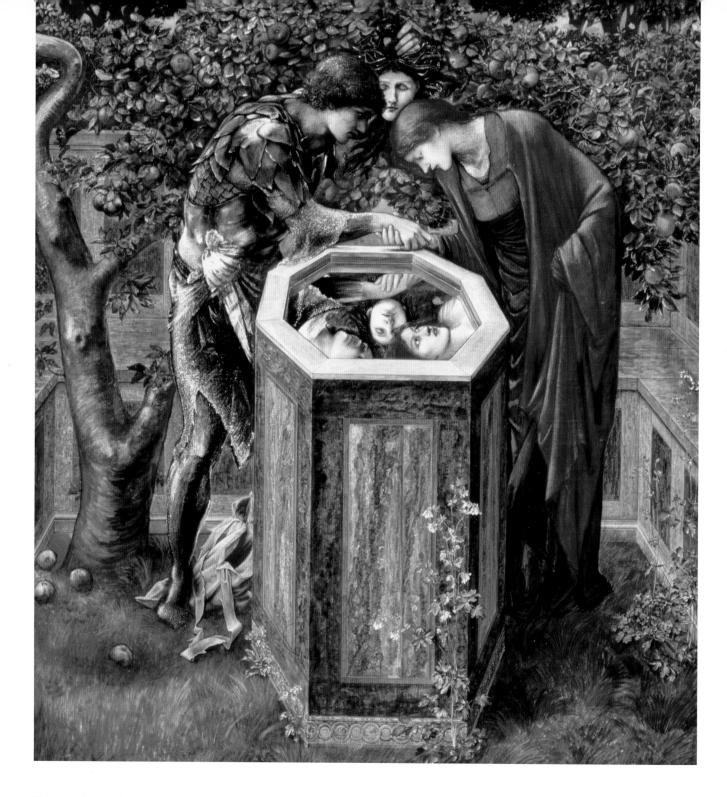

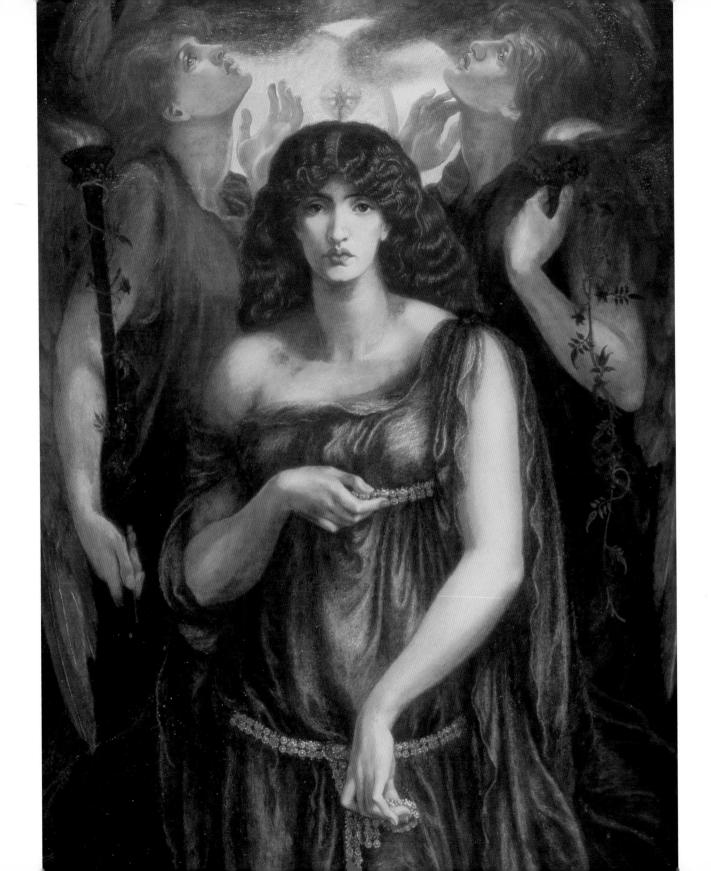

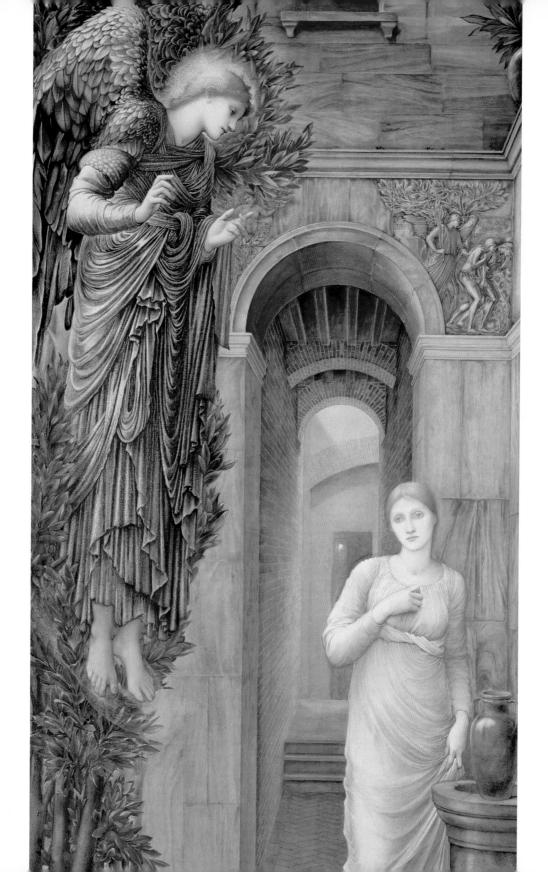

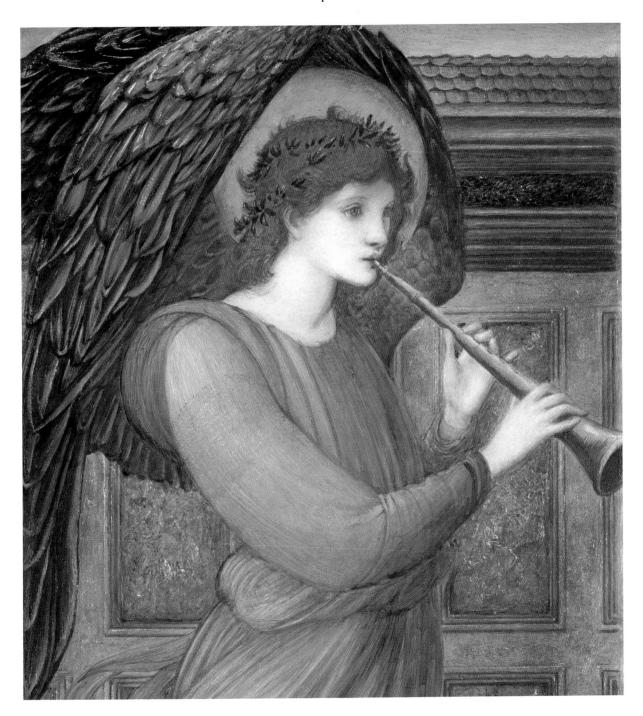

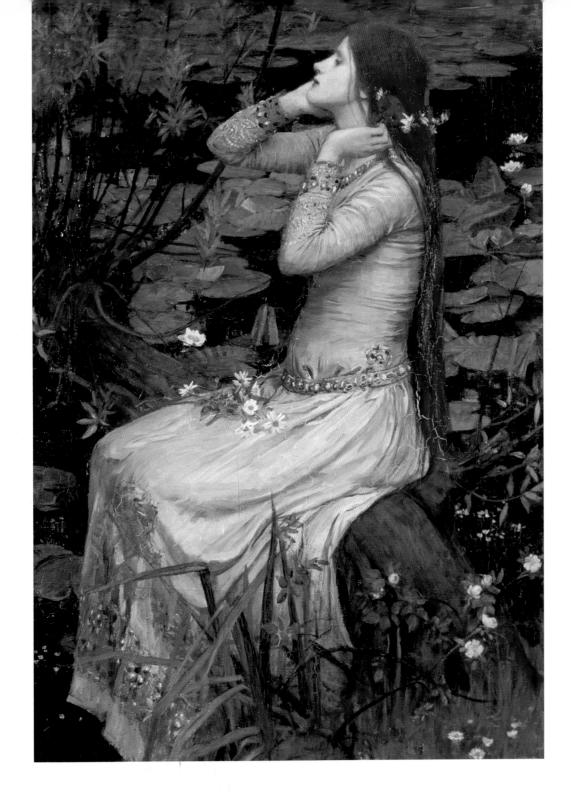

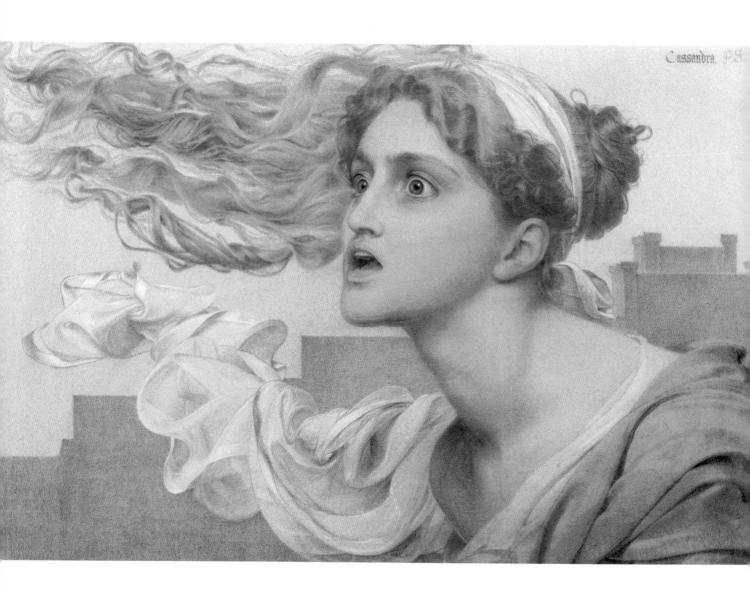

Anthony Frederick Sandys (1829–1904) Cassandra, c. 1895

© Private Collection/Photo © The Maas Gallery, London/ The Bridgeman Art Library

Medium: Watercolour on paper

John William Waterhouse (1849–1917) Juliet, 1898

© Private Collection/By courtesy of Julian Hartnoll/ The Bridgeman Art Library **Medium**: Oil on canvas

(Next page) Sir Edward Coley Burne-Jones (1833–98)

The Mirror of Venus, 1898

© Museu Calouste Gulbenkian, Lisbon, Portugal/
The Bridgeman Art Library

Medium: Oil on canvas

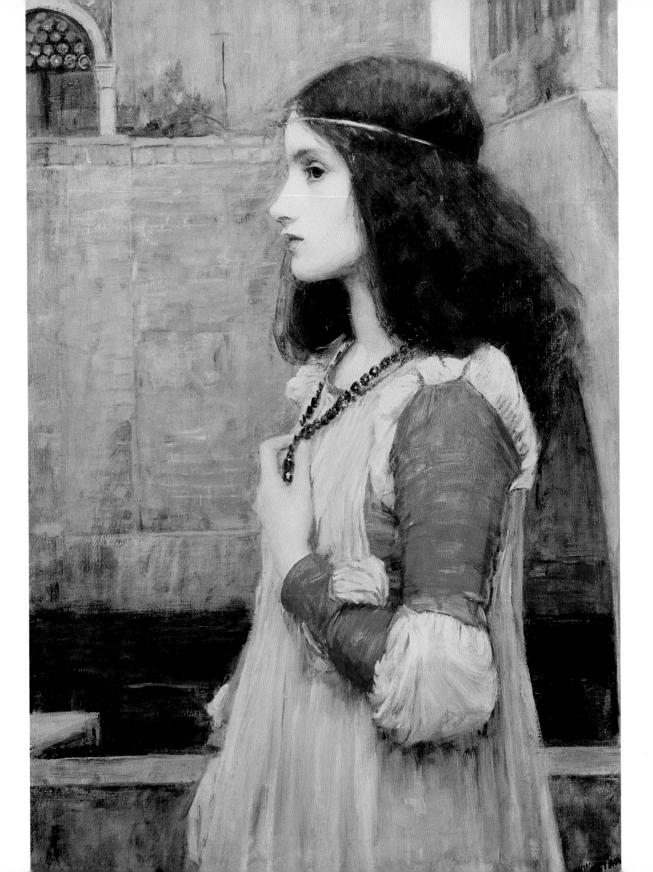

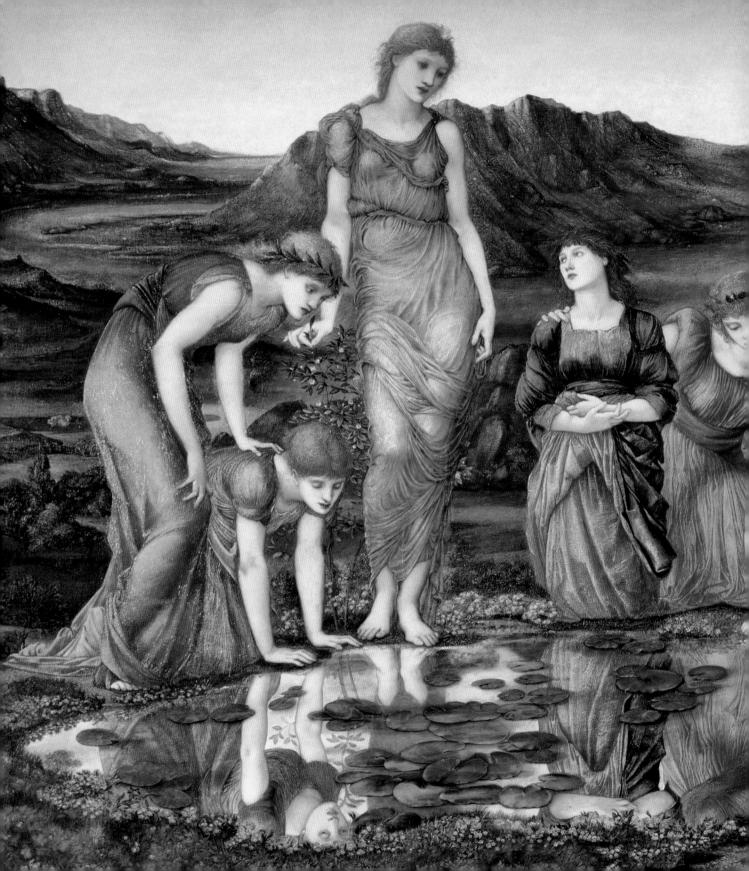

Index of Works

Page numbers in italics refer to captions for illustrations.

Α

Angel, The (Burne-Jones, 1881) 135 Annunciation, The (Burne-Jones, 1879) 135 Annunciation, The (Hughes, 1858) 87 April Love 28, 66 Arthur's Tomb (Rossetti, 1854) 69 Astarte Syriaca (Rossetti, 1877) 32, 132 Autumn Leaves (Millais, 1856) 18, 31, 81 Awakening Conscience, The (Hunt, 1852) 11, 21, 22, 35, 61

В

Baleful Head, The (Burne-Jones, c. 1876) 132
Beata Beatrix (Rossetti, c. 1863) 12, 27, 33, 98
Beguiling of Merlin, The (Burne-Jones, 1874) 13, 32, 129
Black Brunswicker, The (Millais, 1860) 11, 95
Blessed Damozel, The (Rossetti, 1871–79) 32, 33, 123
Blind Girl, The (Millais, 1856) 12, 18, 21, 28, 78
Blue Bower, The (Rossetti, 1865) 33, 102
Blue Silk Dress, The (Rossetti, 1868) 111
Bocca Baciata (Rossetti, 1859) 33, 91
Bower Meadow, The (Rossetti, 1872) 28, 124
Bridesmaid, The (Millais, 1851) 51

(

Cassandra (Sandys, c. 1895) 138
Chaucer at the Court of Edward III (Brown, 1847–51) 39
Christ in the House of His Parents (Millais, 1849) 9, 10, 42
Claudio and Isabella (Hunt, 1850) 46
Convent Thoughts (Collins, 1850–51) 10, 48
Converted British Family Sheltering a
Christian Priest from the Persecution of the Druids, A (Hunt, 1850) 45

D

Dante Drawing an Angel on the First Anniversary
of the Death of Beatrice (Rossetti, 1853–54) 33, 64
Dante's Dream (Rossetti, 1871) 119
Death of Chatterton, The (Wallis, 1856) 78
Doom Fulfilled, The (Perseus Slaying the Serpent)
(Burne-Jones, 1875–77) 131
Dream of the Past, A: Sir Isumbras at the Ford
(Millais, 1857) 18, 83

E

Enfant du Regiment, L' (The Random Shot) (Millais, 1855) 77 Enfant Perdu, L' (The Lost Child) (Hughes, 1866–67) 104 English Autumn Afternoon, An (Brown, 1852–54) 57 Eve of St Agnes, The (Hunt, 1848) 31, 39 Eve of St Agnes, The (Millais, 1863) 98

F

Fair Rosamund and Queen Eleanor (Burne-Jones, 1861) 95 Ferdinand Lured by Ariel (Millais, 1849) 9, 42 Finding of the Saviour in the Temple, The (Hunt, 1854–60) 11, 25, 31, 71 Found (Rossetti, 1853) 65

G

Ghirlandata, La (Rossetti, 1873) 126

H

Heart Desires, The, from the 'Pymalion and Image' series (Burne-Jones, 1868) 111

Hireling Shepherd, The (Hunt, 1851) 28, 31, 53

Home from the Sea (Hughes, 1863) 11, 96

Horatio Discovering the Madness of Ophelia (Rossetti, 1864) 101

How They Met Themselves (Rossetti, 1860) 92

Huguenot, A (Millais, 1852) 11, 59

I

In Early Spring (A Study in March) (Inchbold, c. 1870) 119 Isabella (Millais, 1848–49) 9, 32, 40 Isabella and the Pot of Basil (Hunt, 1867) 107

J

Jack O'Lantern (Hughes, 1872) 123 Jesus Washing Peter's Feet (Brown, 1851–56) 57 Juliet (Waterhouse, 1898) 138

K

Knight of the Sun, The (Hughes, 1859-60) 92

L

Lady Lilith (Rossetti, 1868) 108 Lady of Shalott, The (Hughes, 1873) 126 Lantern Maker's Courtship, The (Hunt, 1854) 71 Last of England, The (Brown, 1855) 10, 74 Light of the World, The (Hunt, 1853–56) 11, 66 Long Engagement, The (Hughes, 1859) 11, 91 Love's Shadow (Sandys, 1867) 107

M

Mariana (Millais, 1851) 10, 22, 51
Mary Magdalene (Sandys, 1858–60) 89
Medea (Sandys, 1866–68) 104
Merciful Knight, The (Burne-Jones, 1863) 96
Mill, The (Burne-Jones, 1870) 115
Miranda (Sandys, 1868) 108
Mirror of Venus, The (Burne-Jones, 1898) 35, 138
Morgan le Fay (Queen of Avalon) (Sandys, 1864) 101

N

Nativity, The (Hughes, 1858) 84

0

Ophelia (Hughes, 1852) 11, *59 Ophelia* (Millais, 1851–52) 28, 33, *55 Ophelia* (Waterhouse, *c.* 1894) *137*

P

Pan and Psyche (Burne-Jones, c. 1872–74) 124
Pandora (Rossetti, 1869) 112
Paolo and Francesca da Rimini (Rossetti, 1855) 74
Peace Concluded (Millais, 1856) 81
Pia de Tolomei, La (Rossetti, 1868–80) 26, 112
Portrait of Elizabeth Siddal (Rossetti, 1854) 12, 69
Pretty Baa-Lambs, The (Brown, 1852) 61
Prioress's Tale, The (Burne-Jones, 1865–98) 102
Proscribed Royalist, The (Millais, 1852–53) 63
Proserpine (Rossetti, 1882) 33, 137

R

Renunciation of Queen Elizabeth of Hungary, The
(Collinson, James 1848–50) 41
Rescue, The (Millais, 1855) 77
Return of the Dove to the Ark, The (Millais, 1851) 48
Rienzi Vowing to Obtain Justice for his Younger Brother,
Slain in a Skirmish (Hunt, 1849) 9, 32, 44
Roman Widow, The (Rossetti, 1874) 129
Romeo & Juliet (Brown, 1870) 115

S

Scapegoat, The (Hunt, 1854) 11, 25, 35, 71 Shadow of Death, The (Hunt, 1870–73) 115 Sleeping Beauty, The, from the 'Briar Rose' Series (Burne-Jones, 1870–90) 13, 119 Stages of Cruelty (Brown, 1856–90) 83 Stonebreaker, The (Brett, 1858) 87 Stonebreaker, The (Wallis, 1857) 19, 84

T

Twelfth Night, Act II, Scene IV (Deverell, 1850) 46

V

Val d'Aosta, The (Brett, 1858) 27, 89 Valentine Rescuing Sylvia from Proteus (Hunt, 1851) 28, 54

W

Wheel of Fortune, The (Burne-Jones, 1875–83) 131 Woodman's Daughter, The (Millais, 1851) 10, 53 Work (Brown, 1852–65) 21, 63

General Index

C Page numbers in italics refer to captions for illustrations. Hastings, Sussex 27 Carlyle, Thomas 29 Haydon, Benjamin 30 A Carpaccio, Vittore 27 Académie de Peinture et de Sculpture 16 Herbert, Ruth 27 Chartists 19 Académie Suisse 7 Hoe, Richard M. 23 Chaucer, Geoffrey 23, 32 Aesthetic Movement 12, 13, 18, 34-35 Hogarth, William 15 child labour 20 Alfred the Great 32 Holy Land 11, 24-25, 31 Collins, Charles Alston 10, 41, 48 Alma-Tadema, Sir John 12 Homer 32 Collinson, James 8, 10 American Church, Rome 27 Household Words 9 colour 30 Arnold, Matthew 34 Hughes, Arthur 11, 28, 29, 59, 66, 84, 87, 91, 92, 96, Combe, Thomas 25, 29 Art Journal 9 104, 123, 126 Communist Manifesto 19 Art Nouveau 35 Hunt, Edith Holman 32 Arthurian legend 32 Constable, John 16 Hunt, William Holman 6, 7, 9, 19, 21, 22, 23, 28, 32, Arts and Crafts 13 Cornforth, Fanny 12, 32, 33 35, 39, 44, 45, 46, 53, 54, 61, 66, 71, 107, 115 Ashmolean Museum, Oxford 29 Crane, Walter 15 Holy Land 11, 24-25, 31 Athenaeum 9, 16, 21 critical reception 9-10 Italy 27 wet-white technique 30-31 В Baudelaire, Charles Dante 6, 26-27, 32 I Les Fleurs du Mal 35 De Morgan, Evelyn 12 Impressionism 18 Bazalgette, Joseph 24 deprivation 19-21 Inchbold, William 27, 119 Beardsley, Aubrey 35 detail 31 Industrial Revolution 14, 18-19, 22, 23 Beeton, Isabella International Exhibition 1862, London 13 Deverell, Walter Howell 10, 29, 46 Mrs Beeton's Book of Household Management 21 Italy 26-27 Dickens, Charles 9 Blake, Sir Peter 13 Blake, William 16 David Copperfield 21 Book of Job 32 Dyce, William 11 **Jesus Christ 32** Bowler, Alexander 11 Brett, John 27, 87, 89 British Empire 22-23 Egg, Augustus 25 Brontë, Emily Wuthering Heights 34 Keats, John 9, 29, 32 Emms, John 15 Brotherhood of Ruralists 13 Kelmscott Manor, Oxfordshire 29 Engels, Friedrich 19 Brown, Emma Madox 32 Kelmscott Press 23, 29 Brown, Ford Madox 7, 10, 11, 12, 21, 25, 39, 57, 61, Kent 28 63, 74, 83, 115 Koenig, Friedrich 23 Fildes, Sir Samuel Luke 15 Browning, Robert 32 Bulwer-Lytton, Edward Foundling Hospital 15 Rienzi 32 Fra Angelico 27 Landor, Walter Savage 32 Burden, Jane see Morris, Jane Free Society of Artists 15 Landseer, Sir Edwin Henry 15 Burne-Jones, Edward 12, 95, 96, 102, 124, 111, 115, 119, Lasinio, Carlo 26 129, 131, 132, 135, 138 G Layard, Austin 25 Aestheticism 13, 35 Gainsborough, Thomas 15 Lear, Edward 25, 28 Arthurian legend 32 Germ, The 8, 9 Leonardo da Vinci 32 Italy 27 Goethe, Johannes Wolfgang von 7, 32 Lewis, John Frederick 11, 12 Kelmscott Chaucer 23 Gothic Revival 34 life drawing 7 Oxford 29 Gray, Effie 18, 25 Liverpool Albion 12 Red House 28 London 24

Grosvenor Gallery, London 13

Gutenberg, Johannes 23

Louis XIV 16

Burne-Jones, Georgiana 27, 32

Byron, Lord George 7

M	formation 8	Shakespeare, William 7, 9, 32
Malory, Sir Thomas	Italian inspiration 26–27	Shelley, Mary Frankenstein 34
Le Morte D'Arthur 29	lasting influence 13	Shelley, Percy Bysshe 29, 32
Marx, Karl 19	literary sources 32	Siddal, Elizabeth 12, 24, 27, 32–33
medieval themes 22, 31, 33-34, 35	naturalism and realism 31	Soane, Sir John 16
Millais, Euphemia 32	second phase 12–13	society 14–15, 18–19
Millais, John Everett 6, 7–8, 9, 10, 12, 19, 21, 22, 23, 24,	social commentary 21	deprivation and poverty 19–21
28, 31, 33, 32, 40, 42, 48, 51, 53, 54, 55, 59, 63, 65, 77,	subjects and themes 31–32	women 21–22
81, 83, 78, 95, 98	sunlight 31	Society of Artists 15
Associate of the Royal Academy 11, 24	wet-white technique 30–31	Spencer- Stanhope, John Roddam 12, 29
Chill October 26	Prinsep, Val 29	Stanhope, Lord Charles 23
Italy 27	printing presses 23	steam power 23
John Ruskin 17–18, 25	prostitution 21, 22	Stephens, Frederic George 8, 10, 28
landscapes 25–26	Pugin, Augustus 34	Stevenson, Robert Louis
Order of Release, The, 1746 11		Dr Jekyll and Mr Hyde 34
Oxford 29	R	Stillman, Marie Spartali 12
Sound of Many Waters, The 26	Rae, Henrietta 15	Stuckism 13
Miller, Annie 12, 27, 32	railways 28	Suisse, Père (Charles) 7
Moréas, Jean 35	Raphael 26	sunlight 31
Morris, Jane 12, 27, 32, 33	realism 31	Surrey 28
Morris, Marshall, Faulkner & Co. 13, 31	Red House, Kent 28	Sussex 27–28
Morris, William 12, 13	revolution 18-19	Swinburne, Algernon 35
Kelmscott Press 23, 29	Reynolds, Sir Joshua 8, 15, 16, 30	Symbolism 13, 35
La Belle Iseult 32, 34	Rossetti, Christina 6, 10, 11, 33	2 10000 000 000
Oxford 29	Rossetti, Dante Gabriel 6-7, 23, 24, 33, 64, 65, 69, 74,	T
Red House 28	91, 92, 98, 101, 102, 108, 111, 112, 119, 123, 124, 126,	Tate Gallery, London 14
Moxon, Edward 23	129, 132, 137	Tennyson, Lord Alfred 23, 29
Mulready, William 30	Dante 26-27	Thackeray, William Makepeace 32
Marcady, William 50	death 12	Times 9, 10, 16, 17, 23
N	Elizabeth Siddal 12, 24, 27, 32-33	Tintoretto 27
Nabis 35	Oxford 29	Turner, Joseph William Mallard 14, 16, 17, 28, 30
National Gallery of England 14	Red House 28	
naturalism 31	Symbolism 13, 35	V
Nazarenes 8, 9, 34	The Girlhood of Mary Virgin 7, 9, 32, 33	Val d'Aosta, Italy 27
Nature 165 6, 2, 54	Rossetti, Maria 6	Victoria 14
0	Rossetti, William Michael 6, 8, 10, 26, 33	Victorian art 14–15
Oxford 29	Royal Academy of Arts 6, 7, 14, 24, 30, 31	
Oxford Union 12, 29	1848 Summer Exhibition 7	W
5.11.01d 5.11.01d 12, 27	1849 Summer Exhibition 9	Wallis, Henry 19, 78, 84
P	1850 Summer Exhibition 9	Washington, George 32
Pater, Walter 34, 35	1851 Summer Exhibition 9, 16	Waterhouse, John William 12, 137, 138
Patmore, Coventry 17	formation 15	Webb, Philip 28
Pollen, John Hungerford 29	schools 16	wet-white technique 30-31
Post-Impressionism 35	Ruskin, John 6, 8, 11, 25, 31	Whistler, James McNeill 18, 35
poverty 19–21	James McNeill Whistler 18	Wilding, Alexa 32
Poynter, Sir Edward John 15	Modern Painters 16, 27	Winchelsea, Sussex 28
Pre-Raphaelite Brotherhood (PRB) 6	support of PRB 10, 11, 12, 17–18, 23	women 21–22
aims 8	The Stones of Venice 27	Woodward, Benjamin 29
attention to detail 31	\$	Woolner, Thomas 8, 10
break-up 10	Sandya Anthony Fraderick 90 101 104 107 109 139	Wyatt, James 29
colour 30	Sandys, Anthony Frederick 89, 101, 104, 107, 108, 138	7
critical reception 9–10	Sass's Academy 7	Z
female Muse 32–33	Scotland 25–26 Scott, Walter 7	Zambaco, Maria 32
Tomate Place 02 00	Scott, Walter /	Zoffany, Johann 15